Inner Journeying through Art-Journaling

of related interest

Spirituality and Art Therapy
Living the Connection
Edited by Mimi Farrelly-Hansen
Foreword by Deborah Bowman
ISBN 1 85302 952 1

**Self-Healing Through Visual
and Verbal Art Therapy**
R.M. Simon
Edited by S.A.Graham
ISBN 1 84310 344 3

**The Therapeutic Potential
of Creative Writing**
Writing Myself
Gillie Bolton
Foreword by Sir Kenneth Calman
ISBN 1 85302 599 2

Grief Unseen
Healing Pregnancy Loss through the Arts
Laura Seftel
Foreword by Sherokee Ilse
ISBN 1 84310 805 4

Clayworks in Art Therapy
Plying the Sacred Circle
David Henley
ISBN 1 84310 706 6

Psychotherapy and Spirituality
**Integrating the Spiritual Dimension
into Therapeutic Practice**
Agneta Schreurs
Foreword by Malcolm Pines
ISBN 1 85302 975 0

Spirit and Psyche
**A New Paradigm for Psychology, Psychoanalysis,
and Psychotherapy**
Victor L. Schermer
Foreword by Kenneth Porter
ISBN 1 85302 926 2

Inner Journeying through Art-Journaling

Learning to See and Record
your Life as a Work of Art

Marianne Hieb

Photographic illustrations by Mark D. Thellmann
Pen and ink drawings by Marianne Hieb

Jessica Kingsley Publishers
London and Philadelphia

First published in 2005
by Jessica Kingsley Publishers
116 Pentonville Road
London N1 9JB, UK
and
400 Market Street, Suite 400
Philadelphia, PA 19106, USA

www.jkp.com

Library of Congress Cataloging in Publication Data
Hieb, Marianne, 1946-
 Inner journeying through art-journaling : learning to see and record
your life as a work of art / Marianne Hieb.
 p. cm.
 Includes bibliographical references (p.) and index.
 ISBN-13: 978-1-84310-794-1 (pbk. : alk. paper)
 ISBN-10: 1-84310-794-5 (pbk. : alk. paper)
 1. Art therapy. 2. Spiritual life. I. Title.
RC489.A7H54 2005
616.89'1656—dc22

 2005019353

British Library Cataloguing in Publication Data
A CIP catalogue record for this book is available from the British Library

ISBN-13: 978 1 84310 794 1
ISBN-10: 1 84310 794 5

Printed and Bound in Great Britain by
Athenaeum Press, Gateshead, Tyne and Wear

To my friend, Helen, without whose faithful support art-journaling would never have been born, and for my parents, John and Mary.

In memory of Dad, a creative seer, and Mom, who delights in words.

Contents

Acknowledgments

Like any other work of art, this book created itself as I worked on it. I began the manuscript with a firm plan, but a myriad of tiny nudges within and without emerged, changing the focus, clarifying the process, creating something new. I am familiar with this happening with a painting; it stunned me that it also occurred in a work of writing.

I am so grateful to Jessica Kingsley Publishers for enabling this long-held dream of mine to go forward. To have the art-journaling process in a written form and to send it out into the world is awesome.

My editor, Leonie Sloman, is such a blessing. I first heard her gentle voice on the phone from across the sea. Ruth Ballantyne continued the editorial process with her reassuring communications, shepherding this work along its way. My sincere thanks goes out to the many other people at JKP whose diligent work and expertise brought this book to completion.

The most important acknowledgment goes to Helen Owens, OSF, my friend and fellow retreat facilitator. For over twenty years she has encouraged me to develop and present this work, and has made possible many opportunities that have pushed the project forward. I am indebted to her and to the milieu of Lourdes Wellness Center, the playground of art-journaling's childhood.

Thanks to Michele A. Piccinini who typed the early manuscript long before I knew anything about word-processing, and whose generous eye proofed, formatted, and revised many subsequent versions with characteristic excellence.

My gratitude extends to Andy and Rachel Hieb, Frederick Franck, Pierre Teilhard de Chardin, and my dad, John Hieb, who taught me about seeing; and to Patricia Corkery, RSM, Thomas Merton, and my mother, Mary Hieb, who taught me about words; and to Ethel Sweeney, RSM, who introduced a high school student to the design elements of art which have been an unending source of fascination ever since; and to Margaret Ellen Burke, SC, who one day asked me to hold art and writing before the Mystery, and that changed everything.

Mark Thellmann is an extraordinary photographic artist, writer and friend. He searched out and captured design elements in nature. He photographed my line drawings and examples of art-journalings. He set up and visually translated icons and sculptures to add their stories to this work. Mark's contribution to so many aspects of my creative work is ongoing and invaluable. He and his wife, Charlene, generously lent their space and insight to this project, stirring and yielding more beauty and truth in our world.

Thanks to Sydney Hieb and to Judy Bowers, who allowed me to use their art-journaling meditations in a most direct way. The other artwork and stories included in this book are composites of individual experiences. Details have been altered to ensure confidentiality. In most cases, I have reinterpreted the original art to present an example, while maintaining the private nature of the work.

My line drawings scattered throughout the text serve as visual presences. They wanted to come along for the journey.

Amy Woodworth, President at Crystal Publications, Glenview, Illinois, granted permission to lean heavily on *Elements and Principles of Art: Teacher's Guide* (Crystal Publications 1996a). Thanks to that gift, I was able to weave both definitions and examples from that source into my meditations on art language in Chapters 4 and 8.

Judy Hewett read the manuscript right before its foray into the light. Her insights caressed the edges, polishing, and sanding places with quiet attention and expertise. Her gaze is creative.

This has been a project of long duration, and so there are many who will be missed in the thanking. Early seeds were sown through my work with Presence and its former editor, Susan Jorgensen. Carol Jean Vale, SSJ, unwittingly facilitated the first draft by engaging me as a keynote presenter at Spiritual Directors International Symposium before I could fully realize the impact of that opportunity. Other serendipitous encounters still continue to move and bless this endeavour.

I am grateful to Jon and Marilyn Hieb who give the support that only family can; and to Beverly Chabalowski and Roberta Cream who enable us to take Lourdes' creativity ministry on the road.

I rejoice in the ongoing individual and communal support I receive from my community, the Sisters of Mercy, and especially from Christine McCann, RSM. Members of leadership, past and present, especially Ann O'Connell, Patricia Carroll, Marie Michelle Donnelley, and Rita Powell, RSM, have supported this project, as have Ellen Murray and the McGranahan sisters – Mary Thomas and Marguerite. I thank them and many others for more levels of encouragement that I can list here.

I hope in the Creator Spirit who hovers over the chaos, making all things new.

Introduction

Evolution of a practice

Armed with oil pastels, journaling supplies, and more than a little trepidation, I introduced a meditative exercise at a weekend Human Wholeness Retreat sponsored by our Lady of Lourdes Wellness Center in 1980. Despite their initial reluctance to "draw and write", the participants came away with authentic insights and clarifications. From that bright day until now, the contemplative practice that I have come to call art-journaling has matured, honed into a sensitive tool. It is this instrument, this tool that you take up today as you begin your journey through these pages.

My work with art-journaling is a blending of interest, study and grace. I am fascinated with the ways that spirituality and creativity intersect. My areas of study are the fine arts, art therapy, and spiritual direction; grace is the catalyst, interacting with these puzzle pieces. The retreat ministry has always entranced me. When the opportunity arose to design and staff a retreat component at Lourdes, I gleefully volunteered.

Human wholeness retreats

Through the hospital's Community Health Education Department, we decided to offer a live-in experience of holistic spirituality. We invited practitioners from a variety of health disciplines to facilitate a program that would incorporate good nutrition, exercise, stress reduction, meditation and relaxation components. My task was to come up with something parallel that would involve creativity in an overt way. I designed a life-style assessment using art materials and written journaling. The pages that follow introduce you to that assessment and to a practice that will illuminate your own inner wisdom.

Tracing some roots

The seedlings of art-journaling practice are rooted in my early experiences. Like most small children, I drew as a natural way of communicating.

A recent encounter with a six-year old brought me back into that world. With notepad in hand, Sydney spontaneously interviewed me. "How are you feeling?", she asked. I replied, "Happy."

In response, she drew a spiky sun on the page. She asked me why I was feeling happy. I said it was because I was with my friend, Sydney. She looked up from her work startled, and then drew two faces. The first was larger and had a smile and straight hair. The second, smaller, had curly hair. She told me, "This is you and me." It was amazing to me that this tiny child had represented herself as the larger circle. As we gazed together at

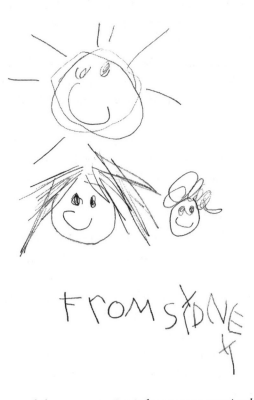

Figure 0.1 Sydney recorded our conversation in her spontaneous visual language, revealing a glimpse into a moment of self-understanding

her drawing, I read her message. She was a grinning presence on the page, looming large. She knew her significance and value. She became the authority. "I want you to sit next to me at dinner," she said. She accepted her power to choose, and bestowed on me a reward.

Sydney is caught up in a process, communicating with her own inner vision and also with me. Sydney is engaged in a journaling practice, translating our conversation into images and telling herself something about her own inner perception. Her wisdom bubbles up, revealing a truth that I am privileged to witness.

When Sydney's dad, Andy, was little, he taught me another kind of seeing. We were meandering down a neighborhood street when he lagged behind, engrossed in something at ground level. Walking back to his crouched form, I saw the objects of his attention. "Andy-worms!" was my response as we watched a pair of earthworms make their way toward safety. Looking up, he shared his matter of fact observation: "They're beautiful, some of them." And then we continued our stroll, silently letting this encounter with a different kind of beauty settle.

When words were still very new to her, my niece, Rachel, invited me into another component of art-journaling. I was holding her toddler-self and we went outside into the fresh air. The sky was transparent that day, and Rachel pointed upward and cried out, "Moon, moon." In the fullness of daylight, that planet hovered and my niece had delighted in giving the moment a name. Rachel was caught up in gazing and pulled me into that encounter. Because of a child's contemplative noticing, I saw the moon anew.

It is within your ability to transform each day by a moment-to-moment awareness of the magic revealed in the light. Through the pages of this book, I hope to gaze with you as the face of your inner self expands with a spontaneous grin. I want you to find beauty in unexpected places and rediscover the moon shining in the daylight.

Children know

In memories from my own childhood, I can recall using a stubby pencil on stationery to translate my experiences into lines. There is one enduring memento of that practice carved into the surface of my father's writing desk. Evidently, I became impatient while waiting to leave on a family vacation. Left to my own amusement as my parents packed, I used my

Dad's car keys to etch in wood a lovely drawing of two people taking a walk.

As you can imagine, this art expression was not a welcome sight to the adults who discovered it. Luckily, the trauma of their response was not enough to discourage my expressive journaling practice. Considering the context, the memory only strengthens what I know of art-journaling's power to keep pace with the multi-layered realities of the everyday.

I had a child's encounters with nature, learning the stories hidden under fallen leaves and tracing the paths of curling vines. As I grew, so did my experiences with a variety of art media. I remember working with a piece of clay and listening to the wisdom of stretching, breaking, and remolding it into a new form. In a natural response, I began writing down these insights, describing them in terms of the creative process so as not to forget their lessons. In my own simple way, I was beginning a life-long practice of art-journaling.

Long before I had words to describe it, years before I coined the phrase that would give it life outside of my young experience, something ancient in me recognized the "feel" of the spiritual. When I was drawing the contours of a growing leaf, or caught up in a process of working with clay, or mapping out the shapes of an inner imagining, in my dialogue with the line, form and color I began to sense the voice of Wisdom.

The concentration, the contact with nature, the expressive silence, and the contemplative time taught me about the Holy. Inspiration flowed from gentle movements that would take an art idea out of my hands and transform it into a sacred parable. As a fledgling art student, I would be surprised as veils of technique would unexpectedly move aside to reveal wonder and awe. This way of touching the sacred would break into an ordinary act of art-making, teaching me in ways that I had neither planned nor expected. Keeping a written response to these mysterious workings became routine.

Getting from there to here

Educational and professional building blocks created the path upon which I now find myself. After early college encounters with literature, I spent several years teaching. Following that, I painted and sculpted my way into a Masters of Fine Arts program. It was then that I discovered the field of art therapy.

It was enough to turn a corner. I began interning at an inpatient psychiatric unit to obtain the supervised hours needed to become a registered art therapist. Suddenly, I was thrust into a world rich in mystery, suffering, and amazing resilience. The scope of patient interactions was wide. I was challenged not just with the mental and emotional contexts of the clients, but also with their spiritual landscapes. Through witnessing their struggles and triumphs, my awareness of a transcendent presence grew and eventually prodded me to study spiritual direction at Shalem.

Shalem Institute of Spiritual Formation is an ecumenical program geared to seekers. During the two years that I was intensely connected there, my experience of the numinous deepened. The sameness of our spiritual yearnings became evident as people from a variety of traditions prayed and shared contemplative practice. It was at Shalem that I began to articulate the prayer of art-journaling as a core meditation practice in my own life. Eventually, I sealed my profession by completing a degree in spiritual direction. My dissertation explored the discipline of art-journaling as a way of prayer and a tool for spiritual direction. During this time, I moved to a job at Lourdes Wellness Center. I gaze on the confluence of these life-pieces with amazement. As the wellness retreat program at Lourdes grew, so did my art-journaling practice. Every time I facilitated this method, the participants shared more examples to back up my conviction. In explaining the process to others, my own words began to grow in meaning. The more I presented this to a gathered community, the more I gained insights into the actual workings of such a succinct, yet profound, practice. What I know about art-journaling today is the result of the shared wisdom of hundreds, if not thousands, of people who spent days, weekends, weeks, and years working in this meditative way, and then articulated their insights, struggles, and sheer moments of grace.

Now, bringing art-journaling as a prayer form to you, I share my belief that our innate creativity is at the heart of spirituality. I propose that inspiration is closer to us than we suspect, and that the Holy is ever ready to reveal its presence when we take a moment to invite wisdom.

In my practice of spiritual direction, I suggest this tool when people are searching for ways to go deeper. I offer it to you as a place to listen for the authentic voice. During the course of these pages, you might be invited to use color or clay to further a theme that is emerging in your spiritual journey. You might be challenged to utilize line in approaching a

grief or loss that is yet impossible to put into words. You might embark on a contemplative walk of gazing in order to receive revelation from the natural world.

Creativity is at the core of our authentic selves. These simple exercises, and the suggestions scattered through this book, can reveal the edges of mystery in a surprising way.

Invitation
Come as You Are

Your journaling history

Inner Journeying through Art-Journaling holds out a practice of holistic journaling using art materials, gazing, written journaling, and noticing. As we begin our journey together, I invite conversation between travelers. I am curious about your own history of journaling. What is your experience of keeping a written journal? When I introduce art-journaling at our wellness retreats, I ask the participants that question. Many reply that they have kept a journal at one time or another. Some tell me of the high standards they set for themselves, resolving that they will make an entry every day. When they inevitably fall short of their goal, they give up the practice completely.

Others admit that they do not know what to record, or say that they are afraid to put their thoughts down in writing. They worry about the possibility of someone inadvertently finding their journal and reading it!

A few individuals use a journal only at special times, for instance on a retreat, or during an unusual trip. Some write down reflections once a year to mark an event, perhaps their birthday or every New Year's Eve.

If something of these experiences echoes your own, adding non-verbal expression to your writing can bring surprising energy and insights. As has happened with retreat participants, you may find that the versatile method of art-journaling is uniquely suited to your busy lifestyle. It addresses many of the concerns about privacy and a lack of time. It can be creative shorthand, allowing you to tell yourself something that would take much longer if you were putting it down in writing alone.

Lifelong art

What is your history of doing art? People who tell me they are not creative, cannot draw a straight line, are not "artsy", amaze themselves by being the very ones for whom this approach can be quite effective. If this sounds familiar, you may discover great energy unleashed through this practice. In working out of your "shadow side", you will tap fresh resources.

On the other hand, if you are a person with experience in art making, this approach can be quite appealing from the start. Working with art materials is comfortable because you already have some knowledge of technique. You will, however, need to overcome the familiarity you have, your ability to control the outcome. You will have the advantage of knowing the language of design and have greater ease in reading your non-verbal expression. Adding the discipline of the written word to your art expression will force you to articulate the clear meaning that you might not always bring to total consciousness. You will be amazed at the clarity with which you really do communicate with your inner self on a regular basis.

Everyday mystics

We have all had experiences of mystical sight. When I say that to a retreat group, individuals sometimes look skeptical. But after they have some quiet to pray over their histories, they recall moments when the reality of the Holy broke through into their everyday. In this breaking, they caught a glimpse of the sacred.

Often, these mystical visions are mediated through the created world. One woman told how a glimpse of spring helped her feel as if an inner darkness had been illumined. She saw early green shoots pushing up through heavy mulch, displacing the dark ground cover with strong new life. Her husband had died the winter before, and that sight was the first real thing that had touched her with any hope. She marked that incident as the beginning of a healing process.

Elise, a counselor, told the story of being on the beach one autumn day when a soupy fog rolled in. She was quickly surrounded by its opaque whiteness. It only reinforced her sense of spiritual alienation. In about fifteen minutes, the fog began to lift and she saw that a young father

and his baby daughter had been playing nearby in the damp sand, searching for tiny shells. The heavy inner fog that had numbed her feelings began to dissipate. Her inner seeing brightened. She acknowledged the discrepancy between her felt sense of aloneness and the reality of a loving presence close by, merely hidden by the fog. Surprised by an opening into gratitude, she engaged in some personal art-journaling and experienced consolation. This beach encounter was the touchstone for a meditation practice that she has followed since that morning.

Take some time to allow your own memories to arise. What are some times when ordinary mystical experiences formed you? They are places of strength and reassurance toward which you can turn and rest in moments of seeming darkness, in times of sightlessness, and seasons of unfeeling.

Creative timing

Like all approaches to wisdom, art-journaling is not for everyone and not for all times in every life. However, those seasons of discernment, grief, and awe too painful or too exquisite for mere words, are particularly helped by art-journaling. Using images, engaging in parable-seeing, and contemplative gazing are some responses from the discipline of art-journaling that can round out our ways of being faithful in challenging times.

In the Buddhist tradition, thoughts are teased into quiet by the *koan*, an unsolvable riddle that puts the calculating mind to rest (Franck 1982, p.7). The range of approaches used in art-journaling can bring mental activities into momentary stillness. Thoughts are laid aside and insight breaks through into relief and revelation. Art-journaling invites each of us to be with our moment-to-moment becoming.

Languages foreign and familiar

Part of every journey is bridging other cultures and traditions. Traveling brings us in contact with unfamiliar languages. In the encounter with well-meaning companions, if we relax, we can frequently make ourselves understood. We take in the whole *gestalt*, watching a person's gestures, face, and context. So it is with the languages of art-journaling: the language of *design*, of *word*, of *image*, of *gazing*, and of *noticing*. Some of

these tongues will be more native to you than others, but they are all dialects that you know. The language of written journaling is probably the most familiar, or perhaps the language of the image has been more developed in your experience. Gazing is a familiar language, but it will take a little while before you realize that you are doing it with ease. The language of design is something you meet and interact with every day. You will come to know how fluent you are in it. Noticing is the language of grace. Mystery within and beyond speaks, and is spoken to. As clarity emerges, the art-journaling conversationalist develops a willingness to be attentive to this unfolding.

So forge ahead, practicing these languages in a holistic life assessment. Listen to the translations of other travelers along the way. Follow paths and tributaries, creating relevant questions that flow from your journeying. Reach out to the vision within and write the vision down.

Seeking Wisdom as a Creative Journey

The journey and the path

On your life's journey, you wander along paths of seeking. The poetics of the senses help in your quest toward inner wisdom. Listen with the ears of the heart. See with the eyes of the mind.

Seeking wisdom is a creative work. The art-journaling process will offer you a variety of tools uniquely geared to this task. You will become adept at utilizing them as instruments in your own discovery. You do this in artful ways and the process, in turn, forms you, bringing you closer to the person you are becoming.

Becoming

If you are like me, the phrase "self-actualization" might conjure up the prospect of hard or lonely work. It has a mechanical sound to it, like something connected to a complex computer system.

Consider that same goal but with different phraseology, call it the emerging true self. Instead of the clatter of work, you hear echoes of mythology, of the great writings from holy scribes, ancient philosophers, and timeless poets. There is a familiar story of Michelangelo describing his process of sculpture as freeing the form that already existed within the block of marble. This is a good parable for your work of becoming.

Gerald May, in *Simply Sane*, talks about the ways we use building words rather than organic growing words to speak about the human (May 1977, p.9). We set out to fix ourselves, he tells us. We *build* character and *hammer out* difficulties. This type of vocabulary gives the false impression that we can, indeed, construct ourselves through the force of our own wills.

Rather, we are growing organisms, springing from a source and reaching for water, bending toward the sun. Like the seed, we are on a journey toward becoming who we already are. We are uncovering those unmistakable qualities that are core to our unique being. We are mining the gifted jewels of self that sparkle beneath the surface. I no longer believe that our life's task is to change or even improve "self." Instead, I see it as a turning toward, a graced movement bringing us more and more into congruence with the person we were created to be (Merton 1955).

The regular practice of art-journaling can help you in your becoming. It positions you to be present to the themes and questions that resound in your everyday existence. It sets you up to seek the wisdom of your hidden self. It spreads out before your sight the great vistas of life's landscapes.

Visiting inner landscapes

What type of inner landscape might you be visiting? How will you get there? What kinds of questions might you be addressing? What themes will emerge? You do not need to know that now; you need only trust that they will arise for you in your own time. During your quest, you will touch on the deep universal questions of living. At other times, you will engage themes that are specific and time sensitive. Some ways of working might have a longer life within you as you enter into decision-making times and must live with discernment questions, issues of grief, and seasons of loss. Themes that arise from your authentic living form a structure to challenge you as you practice art-journaling. They will help you in the moment to move from insight to insight. The stuff of your life becomes the portal into the adventure of inner journeying.

Defining the discipline

Art-journaling is the use of

- simple art materials
- the language of design
- gazing
- written journaling
- noticing

to help focus, express, respond to, uncover or clarify inner wisdom.

Doing art-journaling can actually be enjoyable. That does not mean that it cannot also be helpful. Too often we decide that unless something is distasteful, or at least difficult, it cannot yield results. Trust the journey and invite the creative muse to stand guard as you venture forward. You are at that wonderful place of readiness, poised to begin.

Do not worry about using art materials. You will be amazed at how easily you will reconnect with the spontaneous child who delights in opening up a new box of colored pastels.

Do not worry about the language of design. You will find that you have the facility to use line, shape, space, and color to speak to yourself in a way that is surprisingly accurate.

Do not worry about working in images. Images will come. Images may be something different from what you have always considered them to be. A wavy line is an eloquent image, signifying something to your soul. A red circle, a cluster of black dots on a white piece of paper, these are the images that could lead your spirit inward, that can give birth to illuminating words. Recall my story of Sydney, the six-year old who plops herself down in front of you, drawing a yellow sun with spiky radiating lines, and a grinning face (see Figure 0.1). When she gives you her drawing, you experience communication in one of its purest forms. You already understand that communication, and appreciate that energy. This familiar realm of images forms your own art-journaling landscape.

Do not worry about gazing. Authentic seeing is restful, energizing, transforming, and completely natural. Seeing will slow you down. Seeing will center you. Seeing will intensify your experiences of the ordinary. Seeing is a creative act.

Do not worry about words. They bring with them their own enchantment. Words take on power in religious ritual, in spells, in altered states, in fairy tales. They are the building blocks of ancient incantations and modern revelations. Perhaps it is precisely because the word is so powerful that we begin our journaling non-verbally. The image sets the stage for the word to enter after some of the clutter has been swept away. The language of design clears the way for a verbal response that comes in at a much deeper, cleaner place. Our words can reveal the mystic intuition uttered and heard at a soul level.

A wellness approach

This is not going to be hard. Other past attempts at healthy practices may have seemed difficult. Getting organized might be hard, dieting might be hard, and exercising might be hard. The things that you have resolved to do for your own wellness may all seem difficult, but this practice will not be hard. In a few minutes a day, you will be able to dialogue with an aspect of yourself, you will engage in contemplative practice, you will gain an ability to gaze in a non-judgmental way, and you will move from grace to grace.

Getting ready

The groundwork is important. Having art supplies that please you is important. Claiming space and time is important. Trusting that your inner self is ready to speak is important, but if you do not yet believe that, a simple willingness to attend to your own experience is enough for now.

Supplying

If you have not done so already, go and find art supplies. Basic would be a set of oil pastels and white paper. You will be using a journal for words

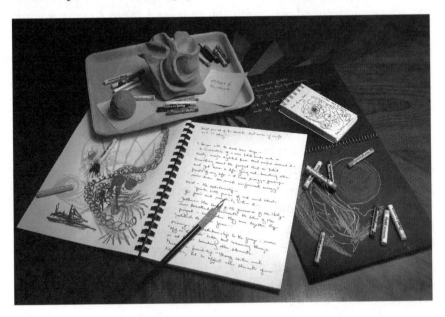

Figure 1.1 Pleasing art and writing supplies, a comfortable setting, space, and time are tools that enhance the art-journaling experience

and a pen to write them. The drawing and writing can be kept in the same book if you wish, or maintained separately, on single sheets of paper in a folder, or in different journals. If a participant asks about continuing with art-journaling, I recommend buying a spiral-bound blank drawing pad, doing the drawing on one side and writing on the other, so that you can see both the expressions simultaneously. From this base, you will branch out, experimenting with styles, sizes, and colors of sketchbook material, with clay and paint, with collage and found art. For today, work with the basics. At workshops, I give out drawing paper and Pentel oil colors, yellow legal pad paper, and pens.

Time

There is a concept of time expressed in the Greek language. *Chronos* time is the time that the clock measures out. As you begin this meditation, make sure you have allowed yourself some quiet, uninterrupted time.

Kairos time is another thing altogether. It is the quality of experience when time stands still, or becomes more expansive. The practice of art-journaling will usher you into both realms of time. You will honor your experience by setting aside real time, but you will be caught up in a process that defies time. In a short period, you might tell yourself something that would take much longer in real time. You may find yourself working for an extended period, and not have a sense of time passing. You may think you have spent a long time and find that it just took several minutes to put down your essential expression. This is your body, mind, and spirit entering into *Kairos* time. It is the time of the soul. It belongs to all creative acts (May 1975) and you will notice it increasingly in other aspects of your life if you engage in it here.

Working from our roots

When you work, keep the roots on. Every year, John Fox, a poetry therapist, presents a Poetic Medicine workshop at our Wellness Center. To help us to write from our authentic experience, he will invariably refer to a poem by Charles Olsen entitled *These Days* that urges us to "leave the roots on" (Fox 1995, p.32). That admonition always strikes me.

What does keeping the roots on mean for our practice of art-journaling? It means not to fear sharing the process, the origins, the *from whence it came* with yourself. One of the many goals of a journaling

practice is to approach freedom. We have heard it said that the truth will free us. To that end, when you engage in art-journaling, leave the roots on. Do not rush to make the image pretty, or to write words that sound good. Do not mask the confusion or the pain if it wants to emerge. Do not minimize the joy if it is there. As you enter the realm of your own truth, that beauty will become evident and will dominate the experience. Follow truth to beauty.

Ancient cultures hold out their visions of a world alive with beauty. The Native Americans talk of the *Beauty Way*. You find the same cadence in timeless Celtic prayers (Fitzgerald 1998). You hear it echoed in music and song, and in the unexpected glimpses of spirit shimmering through nature. Despite your insertion into a world that often shows the face of pain and despair, you can use art-journaling to exercise the muscles of body, mind, and spirit to turn toward beauty. This turning can be creative and sustaining for others and yourself. It can provide reassurance in the midst of desolation and loss, and support for the everyday journey. Once you are in touch with that bottomless well of beauty and truth, your ability to accept and to know your own deep beauty will be boundless.

Inner journeying: the first of many travels

Because of the nature of art-journaling, you are learning it in the best way: by leaping into the experience. Consider a question, work with the art materials, gaze. Explore the written journaling, notice the language of your spirit, and enter into the terrain of your inner wisdom.

When I am introducing art-journaling to a new group, I brace myself for the moment when they come into a retreat space and catch a glimpse of the art supplies arranged at each place. Inevitably, the silence is broken by a sharp intake of breath. Then the inner voices are almost audible as the participants start looking around, perhaps calculating if they can find the exit before it is too late.

As they tentatively settle themselves before the blank paper and box of pastels, I describe my observation of that initial moment, and they laugh, recognizing its truth. No matter what our good intentions, when we reach the threshold of something that could leave us vulnerable, any alternate activity looks better. Even now, you may be saying to yourself: "I won't actually do this exercise just now. I do not have time to find art

supplies and settle down. I'll just read along and imagine what I might do with the pastels, what I might write down. I'll do it later…Or maybe I'll go shopping, or wash the car. And I still have those bills to pay. And it's time to bring in the wash, and check the e-mail." Let me reassure you that I understand. Still, I believe that you have this book in your hands for a reason. Trust this and go in search of a journal, pastels, and writing supplies.

Begin by doing. Allow this initial experience to be the touchpoint through which you will learn and deepen in the process that this book describes. As you move through this book, encountering the aspects of art-journaling, refer back to your own experience. It will be your best key to understanding. This authentic reference place will give clarity to art-journaling descriptions. Explanations and examples will make more sense to you; your understanding will come from your experiential place of interior wisdom.

Before reading any further, even before stopping to do that suddenly urgent errand, say "yes" to crossing this threshold. Honor the synchronicity that brings you and this book together at this precise time in your life. Do the initial exercise. It is the first part of the life-elements/life-dynamics assessment. Completing this will give you a platform from which to discern direction. It will generate questions and themes to move you forward and inward in our journey toward wisdom.

For the sake of description, I have separated the working process into eight parts.

Preparation stages:

1. supplying
2. settling
3. visualizing

Art-journaling stages:

4. posing the question
5. responding with art materials
6. gazing
7. writing
8. noticing.

Art-journaling exercise: life-elements

Supplying

Do you have those art supplies that you dutifully purchased in anticipation of this moment? You will need a box of oil pastels, and two generous-sized pieces of white drawing paper. You will also want something for your written journaling: lined paper or a journal book, and a pencil or pen.

Bring those fresh new colors and challenging white sheets of paper into a space that will become your place to do art-journaling.

Do you want to work at a table? Should you use a drawing board and sit outside? A table, a thick drawing pad, a board, or some other hard surface to lean on will be helpful.

Is there a special corner of your house that will be declared the place of art-journaling? If you have not decided on the space already, take some time to create the place in which you will work. Look for support, not just a table or board, but interior support, and support to not do your ordinary tasks. You are also supplying yourself with time and space, with courage and freedom.

People who attend our workshops tell me that it is easier to come away and do this in a group in which things are provided. If you were coming to me, I would have spent time preparing a place for you. You would have good lighting and something beautiful to look at. Soft background music might be playing. There would be art supplies and enough physical space that you would feel safe to journal in a way that no one else could see. You would have privacy and a time frame in which to gauge a structure for your expression. Set this up for yourself ahead of time. Know that even as I write this, I imagine moving space with you. Come to this time as you would to any prayer, meditation, or self-discovery experience, with intention and openness.

Seek out a place of quiet, give yourself some unburdened time, and respond.

Settling

Settling is just that. The flurry of activity ceases. You might become consciously quiet in body, mind, and spirit. You might lay aside distractions in a meditative way. You might get in touch with your breathing. You

imagine your whole self arriving. You settle. Notice how long this takes. It is a good indictor of the stress level and busyness of your life. Take another moment to settle. Believe that this is within your capability to accomplish.

Light a candle. Put on some music, stare at a beautiful object, close your eyes. Settle.

Gently turn your attention to that deeper place within you, that place of wisdom where the spirit of the sacred exists most truly. Acknowledge that you are in the presence of the Holy. Become aware of the present moment. Focus your gaze.

One of the more telling indictments of our lifestyle is that we do not even have a sense of what it is that helps us to settle. What nourishes us? What do we love to be surrounded by? What particular atmosphere helps us to center? What best expresses our authentic preferences? It may take you a little bit of time to be able to identify this, but you will, I promise you. This practice is the beginning of coming to know those things about your inner spirit. Allow the knowledge to evolve and be open to embracing it.

Visualizing

To prepare, close or focus your eyes. In your imagination, move to a deeper awareness of your life as it is today. Our lives are made up of many colors, lines, and textures. There are aspects of dark and light. There are shapes and forms. For a moment, allow those lines, shapes, and colors to arise in your imagination. When you feel ready, move on to the question.

Posing the question

What are all the elements that make up my life as it is today?

Let the question deepen within you. You are being invited to put lines, shapes, and colors on the piece of paper. These marks will represent every part of your current life. Continue to visualize the quality of the lines and shapes that answer this question. Allow the many "colors and designs" that make up your life to come to your awareness. You may actually visualize colors, or merely have a "feel" of color, in the same way that you sense the difference between a gray sky and a clear blue one or experience, rather than see, the qualities of dawn, dusk, or nightfall.

Do not strain or work at this: rather, allow yourself to stay in a receptive attitude and let those images and qualities of design speak, affecting you in their own way. In your quiet, rest in an appreciation of yourself as part of the beauty and diversity of creation.

Responding with art materials

Respond to the question using the pastels. Remember, you are in the presence of the spirit of wisdom. Take your time. Use your art materials, the language of design, and the gift of your imagination as tools.

As you work, you may find yourself in dialogue with the pastels on the paper. When I visually "answer" this life-elements question, I sometimes find myself thinking such things as, "Well, I have a little bit of this in my life, and a lot of this in my life. This aspect seems disconnected, so I'll put this mark over here in the corner, and I sense an atmosphere of this, and so I will put a little color lightly here…"

Try not to think about this too much. Remember that when you work this way, there is no right or wrong way to proceed, and no correct product. What you put on the paper will probably not resemble any recognizable object or scene. More than likely, it will be a gathering of lines, shapes, and colors that will have meaning to you.

A twenty-minute time frame is reasonable, but you may find you need to devote more time to this section. Conversely, you may finish the non-verbal response in a matter of five minutes.

Gazing

When the non-verbal work with pastels seems finished, gaze at your art-journaling non-judgmentally. Practice a way of presence that is contemplative, open, capable of wonder and awe. Think about Sydney. Imagine any loved child and the way you would look at his/her art with delight. Look upon your own art with that gaze. Try to receive from the design elements.

What do I mean by the design elements? On an intuitive level, each of us has an innate knowledge of design elements and their ability to signify meaning: dark and light, shape and space. Look at the ways you might have used some of them in your drawing.

SCANNING FOR DESIGN ELEMENTS

Scan your art-journaling for the presence of simple lines. Look at the quality of the lines that you used. Are the lines jagged, smooth, broken, or rhythmic and does the way they appear in your journaling have any meaning to you?

Can you identify shapes in your drawing? A shape is a closed arrangement of lines. Are your shapes geometric or organic? Are they large or small?

Sometimes the size of an element can give us clues as to the ways we really perceive things or, on another level, to the way wisdom is inviting us to view some aspect of our lives. Something that seems quite important to you might not appear in a large area of your expressive journaling. Something that seems to have little significance may have taken up a great deal of space on the paper surface.

You may search your journalings to notice relationships. What element or aspect of your life appears adjacent to what other aspect? In relationship to the whole picture, is there an element that seems isolated? Does this have any meaning for you?

What about the presence of energy? Do you have a sense, just from gazing quietly, about the kind of energy that you have expressed visually? Does that correlate with your reality or your desire?

Notice if there are areas of intensity in your drawing. Do you sense this quality in your color use, or do you recall any shift in intensity of feelings as you were engaging in the process? Did you "hear" the drawing?

Does your journaling seem to contain content? Although I encourage the use of abstract representation when you do art-journaling, sometimes there is recognizable content that appears as an appropriate response to the art-journaling question. When that situation occurs, it is important to attend to both levels of the expression. Do not allow the recognizable content to blur your ability to learn from the underlying expression. Notice the ways in which you employed design elements. Even though there might be a representation that looks like a tree, for example, that tree might be rendered in an intense style, or may take up a small space on a large piece of paper, or might be done with either very calm or very chaotic energy lines. We must not forget, in the face of content, to notice those elements that are carriers of expression.

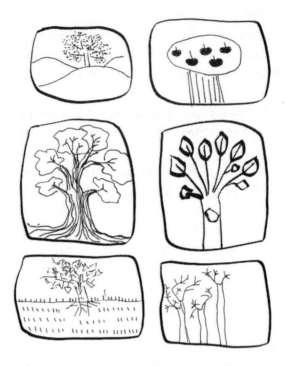

Figure 1.2 The art-journaler listens to the quality of lines and visual space, "hearing" the variety of ways that the image of "tree" is expressed

What about other complexities? Are there areas in your drawing where you used overlays of several colors? Do shapes come together and overlap? In your prayer of gazing, ask the question: are there layers in this aspect of my life? Is there something underneath? Is there something not clear, something that is seeking revelation?

Writing

Take some time to do written journaling to clarify your art expression. Record any answers to the questions or any insights that may have come as a result of your gazing.

If you have a sense that certain colors had meaning for you as you worked, you may want to record that. If you have a strong memory of feeling or emotion triggered during the experience, note that. If there is something you want to think more about, write that down as well. Put into written form whatever helps you to solidify the insights of the prayer.

Record and hold lightly any unanswered questions that may have arisen during this time.

Does a poem emerge? Do you have other questions? Write them down. Pay attention to the verbal flow and record it without judgment. You do not need to do anything about this, just let it be. You are engaged in an inner journey. Honor that.

Title this work, date it, and keep it in a place of reference. Write the question down that you used as a springboard for the art-journaling.

Bring it out again when you move into subsequent journalings and when you consider the elements of design in art in a more intentional way.

Noticing

You have been "noticing" at all points along this process. Noticing is a state of mind, a willingness to keep the questions open. Your noticing deepens the contemplative presence essential to all creative processes. Noticing is different from analyzing. Let go of analyzing. Do not decide on an interpretation of your work in such a way that would close down other insights. Is it difficult for you to remain open-ended? For some people, it is a relief not to draw things to a final conclusion, for others this is very anxiety-producing. Do not cut off wisdom. Organic growth likes slow, evolving movements. Let noticing have space in your life of wisdom.

As the work and words grow in meaning, the noticing continues. Something may reveal itself later, as you turn the drawing to another angle, or make an association between one work and another. There is no restriction on what additional connections might arise in your consciousness as you live with the process. In the next few days, look at people and at nature in a way that fosters an attitude of noticing.

"What are all the elements that make up my life as it is today?" is the first of a two-part life-assessment format. It is a question to which you can return again and again. It nuances the life-changes and movements that may not yet be within your awareness. It makes subtle variations visible. As you develop this practice, you will identify themes specific to your own journey. Ways of finding the next best question will emerge.

Congratulations, you have completed the first part of an assessment exercise, the initial foray into art-journaling. As in all creation stories, see that it is good.

Traveling plans

As you journey through these pages, you will develop your own definition of art-journaling. Through the use of a variety of exercises and art materials, you will gain familiarity with the approaches, seeing which ones delight and enhance your travel. You will become better acquainted with the design elements of art and discover ways to play with them. They are eloquent in becoming parables for many aspects of your life. You will spend some time in their company, here in the pages of this book, in your own non-verbal work, and in the natural world. You will also become re-entranced with the world of fine art, looking at works that hang in galleries. And, most importantly, you will hang new masterpieces in the gallery of your own imagination.

Entering into the Journaling Dynamics

Visual and verbal learning

What did you just do through the life-elements meditation?

- You allowed yourself contemplative time and space.
- You turned your awareness inward.
- You considered a question that posed a theme.
- You responded prayerfully to the question using line, color, shape, and space.
- You spoke to yourself in the language of art.
- You gazed receptively, receiving from the visual communication.
- You spent some time in contemplative writing.
- Finally, you noticed.

Noticing and moving forward

This noticing will continue. By using light and dark, color, dots, lines, spaces, and shapes to yield insight, you engage in visual communication. You return to the organic knowing you had as a child, and translate this into the spontaneous knowledge of an adult. You pave the way for transformative seeing. Images give birth to words, and these words clarify and concretize an inner wisdom that bubbles up from your deepest core. Noticing is the playful and serious component that holds these dynamics together and brings your insights into the future.

The next bend in the road

By completing the life-elements segment of the assessment, you have created a visual shorthand that indicates the most significant pieces of your present reality. As you practice distinguishing and describing the marks that you made, you learn more about what you told yourself. In correlating these marks to a specific life-aspect, you decide if there is a deeper connection.

Let's see how some people worked with their life assessment exercise to determine their next theme. They identified something in the journaling that caught their attention. Based on whatever it was that they noticed, they formulated a new theme or question. These questions propelled them in the direction of inner wisdom. They engaged in a process of traveling from insight to insight, listening for the ways to honor and move forward in their unique path.

Noticing design elements

Eric found that he was able to use the design elements of shape and color as stepping-stones into his next questions.

> I gazed at my first drawing and began describing it to myself. It seemed to be made up of relatively simple, colored shapes. Some of the shapes were connected to each other and a few of them were isolated. The thing that caught my attention was one patch of color unlike the others. This comprised several colors, rather than a single clear hue. I had gone over this particular shape with several different pastels and, as a result, it appeared dense and muddy.

> I went back to my written journaling and discovered that this particular bit of color represented a relationship in my life. As I did some contemplative gazing, I could admit that there was some muddiness in the way we related, some things that were not clear. I am more concerned about it than I realized. I want to formulate some questions to help me continue practicing art-journaling. "What does this relationship look like? What would it look like if I were to let go of my expectations in this relationship?"

Eric formulated these questions based on his reflection on an art element in his journaling. In doing this, he opens up to the possibility of creative

change in himself and in the relationship as he continues his art-journaling practice with the new themes.

Noticing design elements and content

When Marge did her initial drawing, she assigned meaning to each shape as she worked with pastels and paper. Even though her representation began in a flowing style, when she depicted her job, the visual quality changed and that segment on the paper resembled a more defined, boxed-in area containing other rectangular shapes. The shift in style is significant.

While gazing at the finished work, she noticed that the visual area representing her job loomed large. The fact that it took up so much space on the page preoccupied her. The journaling demonstrated how the job seems to encroach on the rest of her life-space. Sensing a readiness, she decided to actively consider her work life.

In this, she is following design elements and content. She created a series of questions that would be specific to dealing with her job.

"What does my work look like? What do my feelings about my work look like? What might it look like if I were to make a change?"

Her art-journalings of these questions eventually moved her into a larger discernment about the desire she had to move in a new direction. Working with the initial life-assessment art-journaling was the catalyst that brought Marge to a crossroad. Entering into the underlying core theme of discernment began when she asked specific questions about the content and design in her life-assessment drawing.

Noticing process

Somatic aspects that occurred in the process of her drawing struck Trudy. As she worked on her life-elements drawing, she was vaguely aware of a feeling of heaviness descending upon her. By the time she finished the drawing, she was weary. At first she did not associate the feeling with the journaling, but soon she made the connection as she wrote about the process. She decided to get to know this feeling. She asked, "What does this *weary* look like?"

Her journaling response to this question depicted three vases. Each held a different style of flower. One of the styles seemed to have more

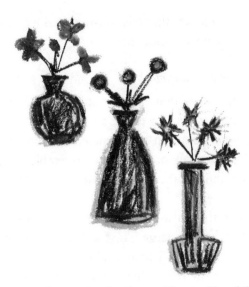

Figure 2.1 This art-journaler associated each pot with one of her children. Her noticing led to identifying conflicts, symbolized by spiky-looking flowers in the lower right vase

intense and aggressive lines. The vases were overworked with patches of uneven surface that reminded her of aging and wearing away.

She associated the three flower vases with her three children. Her relationship with one of them was problematic. The initial assessment drawing brought that aspect of her life to the surface only through the sensation of weariness. Investigating that feeling in a follow-up drawing brought the troubled relationship into stark relief.

After the flowerpot journaling, she took her time considering whether this was the moment to deal with the situation. Once she decided to go forward, she began a series of journalings that touched into some aspects of the relationship. She gained some hard-earned insights about behaviors she needed to surrender.

Eventually, she was even able to share some of her journalings with her adolescent child. The daughter was moved by the attention and concern with which her mother had approached their relating. The discipline of art-journaling created a bridge between them and became a catalyst for the communication that they were incapable of sustaining when they engaged on a verbal level.

Later, Trudy identified her "core theme" as resistance. Resistances are very important places of revelation. They hold energy. One clue to the presence of resistance is the physical manifestation of weariness, and the release of energy when the feeling is encountered.

Your turn: your next best question

Now, refer back to your own journaling experience. The reflection questions on life-elements directed you to notice anything that might stand out. As you gaze at your non-verbal response with the art elements in mind, does anything catch your attention as it did for Eric, Marge, or Trudy? Do you see any patch in which the color appears muddy? Does something stand out as different from the bulk of the rest of the work? Are there changes in style? Is there a remembered feeling that occurred as you worked?

Begin to name for yourself any visual aspect that might be inviting greater clarification. What if you had described a shape as intense, disconnected, vivid, or tentative? If this stands out as unusual, then recall what aspect of your life it signified. Simply wonder if that area of your life is, in reality, more intense, disconnected, vivid, or tentative than some other parts of your life. You use this simple noticing to lead you. You wonder about the deeper level of something that, on first glance, seemed to be an accident of the pastels.

As you practice this discipline, you develop ways of seeing. This work challenges you to creative wondering and sheds light on sparks of wisdom that hide under a variety of guises in your designs.

Record for yourself the questions that may be arising from the noticing in your first drawing. Hold them as future themes to return to as you deepen in this approach.

Continuing the practice

The next part of this assessment exercise is built on the threads of your initial art-journaling theme: "What are all the elements that make up my life today?" The following life-dynamics exercise will lead you into the second question, inviting you to greater clarification of the elements and dynamics of your life.

Art-journaling exercise: life-dynamics

Now that you have moved through the process once, you have know-ledge born of experience. You have greater freedom to choose what works best for you. Again, find the place and time to support your work. Do you want to return to the same place, or are you going in search of another more conducive area? Remember that you will need sufficient, uninterrupted time. See if it is easier this time to give yourself the supports that you need.

Let's revisit the three stages of preparation: supplying, settling, and visualizing; and the five stages of the art-journaling process: posing the question, drawing, gazing, writing, and noticing.

Supplying

Gather your art supplies. What was it like to work with pastels? How did you do the written journaling? Which aspect felt more natural to you? Which approach released more energy? Which one yielded more frustra-tion?

Settling

See if you need to do more to settle than you did the first time. Perhaps now it is easier because you have moved through the initial resistance. Perhaps now it is a bit more difficult, because you realize the outcome of your first work was more revealing than you expected. Perhaps it is about the same and your curiosity enables you to move forward in a way that is not disturbed either way.

Visualizing: using a healing color

For this meditation, you are invited to identify a personal response to color associations. Is there a color that, for you today, would be symbolic of healing? Take a moment with your eyes closed to consider this. Choose this color or let a color choose you!

You may actually visualize this color, see it in your mind, or you may just hold the sense of it in your awareness. However it appears, use it in a relaxation exercise in preparation for the second journaling.

Imagine that you are surrounded by your healing color, and rest into it. When you have a sense of it supporting you from the outside, imagine

breathing it in slowly. First, it enters your body through your breath and fills your head, and then it gradually moves from your head through your neck into your back, down your arms into the trunk of your body through your legs, even to the soles of your feet.

With your body filled with this healing color as a light mist, imagine that it intensifies its presence anywhere you are experiencing pain, tension, disease, bringing the presence of a gentle healing mist to that area.

Next, allow this healing color to swirl in your mind, where there may be stress, worries, concerns, or unfinished things. Allow the color to rest in those places.

Then breathe deeper. Imagine a column that opens up within, accessing a core space, the place of inner authenticity. Let the healing color as a light mist flow down and rest there.

Staying wrapped in a sense of being surrounded and interpenetrated by the healing color, use your pastels to respond to the theme.

Posing the question

Through what elements of my life am I being called toward change or growth or healing?

Let the question expand in your consciousness. Be with whatever shapes and colors, whatever content, whatever sense or feeling comes to mind. If there is just a blank emptiness, be with that as well, and begin your response from that place. Do not be afraid to seek an answer, whether you have a sense of direction or not. Sometimes our most telling work comes out of an emptiness or darkness that yields revelation. In your visual response, use any colors that express your journaling, but be aware of your healing color as you work.

Responding with art materials

Take as much time as you need to complete the visual response. You may find that this takes very little drawing and more writing. You may find that the question is more elusive. You may find that you know exactly where this healing energy is at work in your life. Any response is correct, because it is yours and this is a journaling practice. So, do not stop to

think about what the "right" way is to do this. Art-journaling is a creative structure into which you can fit whatever is most authentic for you.

Gazing

Once this non-verbal response feels complete, gaze on this expression and see what the visual says to you. Receive from the color, the space, and the intensity.

Writing

Write about the process itself, any insights that may have stirred, any noticing through design elements, any interpretation, any physical, mental, emotional, or spiritual sensations that may have arisen, either as you drew, or later as you were gazing.

Noticing

Expand your willingness to stay in a contemplative stance in relationship to your visual and written expression. As you live with this meditation and its companion life-elements journaling, small insights and deeper movements will lead you forward.

Followings: asking the next best question

At the beginning of this chapter you heard the ways that individuals, after completing the first journaling, followed clues that they received from design elements, content, and holistic presence. Based on these clues, they formulated a new question. Any manifestations in design elements, content, or holistic presence may be inviting you as you gaze at your drawing. Use whatever path has the most energy for you as a springboard to take your practice forward.

As the art-journaling stories continue, you will hear more about those ways of creating your next best theme. Along the journey, you will probably traverse all of them. There is no right or better way, just notice which side trip seems most authentic for you at this time. Here are examples that will help you to think about the paths.

Following design, content, and holistic presence

A young woman did a journaling that included a realistic rendition of a rose, complete with green stem and black thorns. She followed both design and content: the design element was the dense black color, the content was the thorn. Her healing color, a lime green, surrounded the thorns. She decided to magnify a thorn to see what other colors might be contained in the intense black. To her surprise, she came upon a troubling experience that held a lot of sharp heaviness for her. The large follow-up journaling depicted darkness connected to a green stem. The stem became identified with her life and the juncture of these two colors, the place at which they met and connected, became the important theme. Some life experience that she had dismissed as of little consequence became a pivotal point of consideration. She continued an art-journaling dialogue with the experience and eventually began a series of poems that transformed her darkness into a creative response. The magnification of the thorn was the decisive move that brought her to knowledge. Being courageous in the face of that knowledge moved her into creativity.

As the follow-up thorn drawing developed, she experienced feelings of sadness. The emotion was yet another clue to the importance of the path she chose. The emotional response indicated another energy, that of holistic presence.

Healing mandala and holistic presence

In following *holistic presence*, the art-journaler pays attention to movements of emotion or physical signals that indicate something beneath the surface. Noreen began by tracing a circle or mandala on her page. Within it, she drew an abstract rendition of the healing presence in response to the life-dynamics theme. When she had completed it, she gazed. The colors were soft and diffuse and no particular element dominated. The overall impression was pleasing and she could rest in the depiction. As she continued to gaze, she imagined the features of a person gazing back at her. It was just the slightest hint of a visage, but she felt consolation and was moved to delight. The experience had a finished feeling about it and her written journaling brought some clarity. The feelings of consolation and delight confirmed a sense that she had experienced growth. This occurred, at least in part, because of strong support that she received from

a mentor. The gentle face emerging in the mandala represented him. She completed several more journalings based on questions that probed a deepening of this growth and was able to claim it with even more conviction: "What does this feeling of contentment look like? What would it look like if I could trust the reality of my own growth? What would it look like if this feeling became part of my outreach? What does the next step on my journey look like?"

Figure 2.2 The mandala or circle shape can help to structure an art-journaling

In your own life-dynamics drawing, you may notice energy from holistic presence, from the content, or from design, and follow one or a combination of those for your next best question.

Following dynamics: change, growth and healing

You may also notice an invitation to follow one of the life-dynamics of change, growth, or healing. The movements of change, growth, and healing are related but distinct. Did one of them speak more forcefully to your current life experience?

Was your emphasis on places of change? You may want to move into themes of discernment, of ways of coping, of accepting, or of being more efficient.

Was your emphasis on growth? What do you need to do to support growth, to acknowledge the positive aspect in your life, and/or to rise to the challenge of growth in a creative way? We can grow from painful experiences. We can grow from gratuitous insights. What is the nature of the growth and in what ways do you need to enhance it?

Was your emphasis on healing? Do you have a sense that something has already begun to heal? Do you have the insight that something needs to be healed, or that you need to reach out in an active way to some situation or relationship? Is this healing on a personal or global level? Is it the healing that is long and dark, and has no real contours? Is it a situation in which you are being called to abide and trust that healing will come? The big sorrows of our life come with this kind of healing. The action is not our own, nor is the timing. Inner wisdom calls us to abide and wait on the slow and organic unfolding of a life cycle that obeys laws not open to our willfulness.

The following stories present ways of working toward themes that hone in on the dynamics of change, growth, or healing.

Following the dynamic of change

After visualizing a healing color in and around her body, Peggy found an invitation. In the journaling that probed the dynamics of change, she identified a challenge to lose weight. Immediately, feelings of helplessness and frustration arose in her. She felt discouraged. This was a recurring and unsuccessful theme in her life. Instead of following the feelings of frustration, which was a possible path she could have taken, she entered into the stronger energy of change. This time she was able to hold the challenge in a positive context. Rather than attack it as a problem to be conquered, she created some art-journaling questions for herself: "What would it look like if I engaged in healthy eating? What does my resistance to giving up unhealthy eating patterns look like? What does nourishment look like? What do I need for nourishment?"

She discovered a larger challenge around lifestyle. She began to probe "hungers" that were related to a larger context than the food she was or was not eating.

Dynamic of growth

Brian was engaged in the written journaling stage for his life-dynamics drawing when it began to dawn on him that he was in the midst of growth. His reflective words helped him to notice not so much what was in the drawing but what was not. To his surprise, the things that had been major troubles in the past did not appear in the visual expression. As he journaled, he realized that he was not as concerned with other people's opinions. He was not as anxious. Through his writing he clarified the presence of a shift in his ability to sustain ambiguity. The realization that former difficulties did not appear in the drawing freed him to claim growth.

Here the growth dynamic was discovered in the written journaling. Brian was able to record changes that he had made, and then move to a place of awareness and gratitude. He encountered a confirmation of changes that he had worked hard to accomplish. His follow-up drawing took on a more realistic style in response to his question, "What does this growth look like/feel like?" The art-journaling depicted a healthy tree in a pleasant landscape. A curving path stretched into the distance, hinting of journeys with promise. In his practice, he began a series of journalings about the path and its possible destinations (see Chapter 6 for a discussion of practice).

Breathing in the healing color

Marla found the use of a healing color very important.

> I used blue as my healing color and imagined being surrounded by it and then began to breath it in. It was very relaxing and I could almost actually feel the coolness as it moved down my body. I was not aware of places of bodily tension or pain. But when I imagined the blue mist swirling in my mind, I suddenly became anxious. The feeling of relaxation left me and I just stopped the visualization. When it came time to respond with pastels, I used colors very lightly. I chose a peach color to represent me and surrounded me with an aura of blue. Then I drew a circle to the right of my body. I filled it with different color squiggles and I put small dots of the blue in between.

> I gazed and decided that the circle probably represented my mind. I know I worry too much about things but I never had the sense that

worry could separate me from my body and take away relaxation. So I asked: "What would it look like if my mind could receive the blue mist of healing?"

Even the question let me know that somehow I didn't want to let go of worry. I am already in a counseling relationship, and so I decided to take the art-journaling to my next session. It feels important and close to what we have been discussing. In using the healing color exercise, I think I finally realized what could be getting in my way.

Each example has identified a primary way to notice and create the next best question. However, none of the follow-up work occurs in isolation, as you can see and hear in each story. Frequently, content, holistic presence, and a dynamic are all in the mix. Part of noticing is to clarify if there seems to be a stronger invitation. Usually there is.

The suggestions for "followings" are just that – suggestions. There is a wealth of rich material that emerges from this gathering of your life in a visual/verbal statement. The elements/dynamics duo can be done over and over again. What you will tell yourself will always be new because you are always changing; your growing edges are never in quite the same place.

You are learning to let the questions emerge from the life-elements and life-dynamics exercises. You have seen and heard a variety of ways to do this. They all have to do with developing visual sensitivity and with the parable power that design elements hold out.

Gazing at the assessment duo

The assessment is made up of the two major themes you have completed:

- What are all the elements that make up my life as it is today?
- Through what elements of my life am I being called towards change or growth or healing?

For the next level of information, place the two journalings together to see if they have an additional story to tell you. Look for aspects that disturb you visually, emotionally, and contextually. Notice what seems off balance, stands out, or is separated. Notice their similarities and differences. Notice if your healing color appeared in the first drawing before you identified it as healing. What does that color represent in the first drawing? Can you make any connections?

Look at the size of things. Sometimes you consider an aspect of your life to be not particularly significant, but when you journal visually you see how large an area it occupies on the paper. This contradiction between how much consideration you give something, and how large a space it occupies on your paper is worth creative wondering. You might even reevaluate your sense of priorities.

Talk to yourself about these different ways of considering your journalings and see if they yield any insights. Do not take the insights lightly; do not dismiss them. You have placed your desire before inner wisdom; it is important to honor whatever nudging is coming to you.

Begin to create your own questions based on your initial assessment. Come back to these two assessment themes whenever you feel the need to notice the essential places. You will find that some elements recede, others ascend in importance, new aspects come in but are very temporary, and other things reveal themselves as the constants of your life.

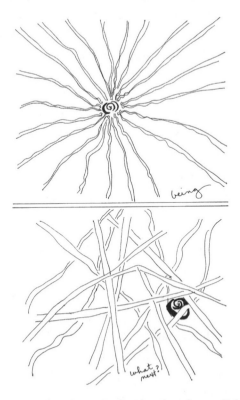

Figure 2.3 These two drawings, done one after the other, show a dialogic progression of design elements, symbols and verbal titles from one composition to the next

Clues from the two drawings together

Anna was in a transitional time in her life. She was seeking some clarity about the next step in her ministry and had taken some sabbatical time to work on the question. To her surprise, she really enjoyed "being" and did not experience a need to move quickly into the next job. So, the first drawing was unlike anything she had ever done. It was made up of a series of colorful lines radiating out from a center. This was an apt symbol for the way she felt about "being." In her second drawing, the lines appeared more connected. They were still threadlike, but the picture had more of an overall woven character. However, as she gazed at both of them, she was a bit disturbed because nothing in either of them seemed to help her with any indication of "what next?" "Although I am thoroughly enjoying it, I can't just *be*," she said with some humor and, perhaps, some regret.

After we chatted a bit, she admitted to being at a turning point. She did not want to return to the same kind of job she had held for years. Considering just one alternative position did not seem adequate. Having many interests, she wanted to entertain a wide range of possibilities for her next career. So she set out to formulate questions that began with the phrase, "What would it look like if..." and completed each phrase with as many wild possibilities as she could imagine. In that way, the direction toward which she might be tending could emerge for her in a playful way, and then she could go back and consider it seriously. This allowed her the freedom to keep her options open, to attend to the process, and still move toward a practical conclusion.

Content

A closed shape that represented a situation in her life dominated Janet's first drawing. She described the form as an alabaster jar. This image reminded her of a story in scripture of a woman smashing open such a jar. Janet wondered what it might look like if this jar, this situation in her life, were to explode. In her next drawing, she used her healing color to create a protective container around the jar. As she drew and dialogued with the image, she began to perceive the jar as an open vase. She began a third drawing, keeping the protective space in place, and drawing a delicate vase within it. A flower emerged and leaned into the edge of the protec-

tive space. She identified this flower as an issue that was important for her to consider. Because of the healing space she had created, the flower was able to emerge, and the issue did not need to explode to get her attention.

Trust your intuitions

The aspect of what to follow in your own life assessment duo is significant. How can you best decide what is the primary movement for you to follow? Listen visually to the areas already mentioned. Are you called toward any art element? It might take a bit of practice to identify them, but as you exercise visual sensitivity, this will become easier. We are not used to giving ourselves this level of attention. It will help in all areas of your life.

You need to develop an awareness of holistic presence. It becomes important for you to scan your body, mind, and spirit awareness during and after you do a journaling. This awareness is crucial as you strive to listen to the wisdom of the body in every aspect of experience.

Expert gazers

Just as is true for these journalers, as you work your way through this book, you will become an expert at gazing at your work. You will discriminate about your learning mode and notice the role that process and product play in your approach to listening. You will discover how much your intuition already knows about design elements. You will exercise your skill in noticing.

In some of the examples, the journaler identified a "core theme." There are times in your life when a significant dynamic is at work. You find yourself in a discernment time, or resistance is operative. There are seasons of grief and loss when that dynamic overshadows. There are times of illumination, when you receive glimpses of the next step, and are able to move forward. These times seem closer to the center core. Your exploration of practice will include some exercises to address core themes in led meditations. In the meantime, you may be aware of the ways that core themes begin to manifest themselves as you work on your next best art-journaling questions.

Art-Journaling as Process and Product

An exploration of perspectives

For our elements/dynamics assessment journalings, we used oil pastels and paper as our art material. However, art-journaling can be done with clay or paint. It can happen in the presence of a powerful image in nature. It may be accomplished by gazing at a sunset or at a twisted branch of a dying tree, visually "listening", and then journaling in words about the experience.

When you walk along a garden path or by the sea, or gaze at the smallest growing weed, or seek the horizon, if you can play with this experience as parable, then you are doing art-journaling. When you respond to an art-journaling question with color and line, if you can receive from this seeing in a non-judgmental way, then you are doing art-journaling. When you work with the malleable medium of clay and gaze at your fingerprints in the earth, realizing your ancestral connection to all peoples of the world, you are doing art-journaling.

Process and product

As you know from your work, art-journaling is a meditative stance before inner wisdom, an exercise in *prayer.* It creates *process,* yields a *product,* invites a *way of presence,* and can become a *practice.* As you look back now on your two art-journalings, expand the definition of art-journaling through your own lens.

Can you notice if your own emphasis was on the process? Were you taught by doing the activity? Did doing the work tap a knowing in your body, mind, and spirit? Did physical, mental, emotional, spiritual, and intuitive sensations arise? Did the process of physical writing or physical art-making bring a particular insight into sharper relief?

Do you think your emphasis was on product? Did the image that appeared on the paper give you the most vital information? Were art elements the main conduits of insight? Did the action derived from your work become the primary outcome? Did you look toward goal or resolution as the product of your work? A person learning through process notices the way she/he arrives at the end point and makes an application; the product-learner identifies a concrete image in that end point and reads its meaning.

Process/product continuum

You may be more conscious of process as you begin. The physical sweep of putting down bright colors energizes you. You work in an abstract way but as you gaze, your eye pulls elements together. In the gathering of colors, something emerges that looks like a group of people. You make a connection with this image and your current life situation. You are learning from both process and product.

Choosing a different medium

Phillip used pastels for the elements/dynamics assessment exercises. Then he formulated his next best question for a follow-up art-journaling. He was so eager to address his own question that he immediately started writing down the answer. He moved into verbal list-making before he could take up the colors. Despite his innate need for verbal clarity, he still wanted to engage the question non-verbally, using imagery as a parallel way of understanding. Accordingly, he changed art materials to see if an unfamiliar medium would help. Earthenware clay was his choice.

Earthenware clay

We can experience art-journaling using clay. The earth, ancient and wise, is a wonderful material for expression. In his account of forming the *Seeker*, Phillip shares a glimpse of this wisdom-process facilitated through insights that the clay was eminently able to provide.

I formulated an open theme to avoid being too intellectual in my follow-up questions. I asked to be led toward insight, then took some clay and began pulling it outward from the center. After I

worked for a short time, I stopped to see what was emerging. The lump of clay began to take the primitive shape of a person kneeling.

I began to refine the form. Fragile arms were raised in a gesture of supplication. A face tilted upward and, with the help of a stick, I indented two eyes. Next, I carved an open mouth. I sat gazing at a figure that was not artistically perfect but one whose gesture spoke to me. After a time, I became unsettled. I began working on the surface of the figure, smoothing, and strengthening it. The upraised arms became straighter and firmer; the back strained upward. I now had more of a sense of the figure's reality and, again, I meditated on this, allowing the changes I had made to reveal to me something of my own journey.

After a time, the same disquiet overtook me. I went back to the figure, and held it quietly, trying to listen to a deeper call. To my surprise, I found myself using more pressure on its surface, until eventually, I worked with my nails, creating a deep, rivulating texture all over the figure. I dug "beneath the skin." Finally, the figure felt congruent. In meditating on this added phase of the sculpture, I sensed a call to go beyond, to break into the seemingly smooth surface of some superficial things in my life. I caught a glimpse of some pain beneath the surface. I called the figure *Seeker*. It speaks to me about my attempts to "smooth over" situations calling for a deeper response that "breaks through the surface."

This making of *Seeker*, and the presence Phillip had in relation to the process and product he encountered, is a good example of art-journaling. Phillip would form some clay, stop, gaze, listen to what the sculpture was saying, and then make adjustments based on what he was hearing. The stages of sculpture-making brought Phillip into deeper and deeper gazing. He came to insight by making external adjustments to the clay, and naming the results of those adjustments as he sought congruency. He demonstrated the active seeing that occurs when we are fully engaged in art-journaling.

The activity of texturing the surface was a revelation. The parable of breaking into the skin was a grace that went well beyond the simple making of a figure. It entered Phillip's consciousness at a deep level, teaching him something important about his life-dynamic. In this meditation, he encountered insights resulting from contemplative dialogue.

Even though Phillip ended up with the sculpture of the *Seeker* as a very significant product, many insights seemed to arise from process. In Phillip's work with clay, he moved back and forth between process and product for the dominant movements that carried the journaling forward.

Changing from pastels to clay freed Phillip from his tendency to engage in intellectual problem solving. When Phillip returns to using pastels for art-journaling, it will be important that he does not deny his giftedness, or devalue his intellectual ability. Art-journaling taps into an energy hidden in our non-dominant approach to expression, but it also enhances natural abilities. Phillip's experience of breaking through the surface will now accompany him as he creates his next questions. His response when using pastels will be more spontaneous. He can capitalize on the strength of his logic and organization and still tap into a flexibility to move between art materials if he wants a less structured approach to a particular theme.

There are benefits to surprising yourself occasionally by replacing one art material with another. As with physical exercise, varying the workout builds different muscles and strengthens the whole body. The simple shifting of the familiar can intensify insight.

Acknowledging unique strengths

When they do art-journaling for the first time, some people express the desire to be more spontaneous. One woman said an image had come to her, but she kept trying to ignore it. She wanted to be open and not think of anything. I tried to emphasize that our gifts are the things that will help us. It is a journaling process. If an image comes, welcome it and work with it.

During a visualization in preparation for the healing drawing, Rebecca received a vivid image of a fountain. When she began her journaling response, she spent time trying to draw it in detail and became frustrated. My suggestion to Rebecca was:

> break your process into stages and do not lose the image. Visualize it and do some written journaling. After this dialogue, then work with art materials, not necessarily trying to reproduce what you imagined, just expressing its "feel." That way the richness is not lost and the frustration can be distinguished from being part of the prayer to just simply being part of the drawing challenge.

Recognizing process

When we engage in art-journaling, we find ourselves caught up in a process, participating and being inspired by something that is dynamic. In Phillip's art-journaling story, he describes making the *Seeker*, and the unfolding of his process led to revelation. Marla learned an important insight from processing feelings that arose from her body and mind as she worked on her healing color journaling. Process is one of the myriad ways through which you approach the mystery of the Holy. How and where does process manifest in art-journaling?

Processes in art-journaling

In art-journaling, we find process:

1. in the doing of it
2. in our holistic presence
3. in the relationship between drawing and writing
4. in a way of seeing
5. in seeming accidents.

Process arises in working with the art materials in a sequential way. In responding to the theme, you begin to apply pastels on paper. This creates a shape. The shape calls forth other shapes, to complement or to oppose your initial inspiration.

As you continue, you might decide to enlarge some portion of the expression. You add a bold line or a subtle background color, and suddenly you have the sense that this is enough; your response is complete, at least for now.

You engage in the activity of putting down color, line, space, and shape. As you work, the design elements speak back to you, telling you what to add, or what to darken, or what to make larger. You listen to the work, allowing the dialogue to lead.

Something happens in the actual physicality of the work of art-journaling. Like Phillip, you might dig at the clay and feel congruent. In a discernment prayer, you might move from light color application into a denser patch of color and begin to notice strong feelings, or energy arise in you.

Answering the life-elements theme, you might decide on the next color to represent an aspect of your life when an entirely new realization arises with clarity and a sense of *aha*! These inner inklings are part of the dialogic aspects of art-journaling. They are processes, dynamic qualities that teach you about the meaning of your work, and lead you deeper into its prayer.

Holistic presence

Art-journaling enhances your ability to pay attention to the wisdom arising from your body, mind, and spirit. Listening for these subtle, or not so subtle, movements is another way that process manifests itself.

Art-journaling as a focus, an expression, or a response can engage our whole selves. Once engaged, you might access sensations and nudgings from the wisdom of the body, inklings and emotions from the mind, and confirmations and discernments from the spirit.

How might this holistic awareness teach you in the art-journaling exercises? As you work, you may notice changes in bodily tension or in relaxation; there may be a minimizing of pain or your awareness of pain might intensify! Perhaps a headache starts when you had none before, or a sense of lightness replaces a feeling of heaviness or burdening.

You may also experience shifts in feelings. Sadness rises up. Feelings of frustration, anger, delight, or discouragement suddenly coalesce in your emotions. In the beginning of your practice, you might associate these feelings with the task, rather than with the content of the meditation. It is helpful to go back in your mind's eye, identifying at what point in your work those internal movements occurred.

Changes may manifest themselves in your spirit. Perhaps something occurs to confirm a decision. You may experience freedom around a challenge. Feelings of congruency, of spiritual grace, or of resistance may solidify. The edge of fear or of loneliness may be resolved into an invitation to trust.

Through process in art-journaling, you become more sensitive to holistic insights. This contemplative listening to your embodied wisdom opens you to significant information. An insight on the physical level might result in your making healthier decisions concerning your lifestyle. You may be invited to make changes to your nutrition and exercise approaches. You may be invited to create some time for yourself. Mentally

you may find clarity and healing as you approach your history in a new way. On a spiritual level, art-journaling could yield moments of illumination or challenges to service. In certain seasons, it might become your primary prayer modality.

Relationship between writing and drawing

The process of writing is core to art-journaling. You use your verbal insights to focus and concretize your non-verbal expression. This relationship between the non-verbal and verbal modalities is essential. It is the primary process through which your work in art-journaling is integrated.

Since it is more likely that an individual is trained in verbal expression, writing is often the stronger gift in a person. When someone uses written journaling exclusively, she/he can be tempted to make it sound good. Writing is a more public modality, and the tendency is to polish expression. This temptation could take one away from an authentic account, forsaking heartfelt words for a clever turn of phrase. Have you ever begun to write about your day, and then changed the choice of words, saying, "Oh, it's not that bad?" Sometimes the directness of writing leads you away from saying something important to yourself. Working with art materials first paves the way for a more honest reflection on a theme.

ENHANCING WRITTEN JOURNALING

Pamela was a young woman who kept a written journal of her life-journey for years. She attended a day of prayer, during which we used the same art-journaling prayer question that you did, "What are all of the elements that make up my life as it is today?" Pamela had a job, some good friends, and a life that was involved with family and community events. Several years ago, she had been diagnosed with multiple sclerosis, but the disease had not intruded on her ability to function in many important areas of her life.

In following the sequence, she settled, meditated on the theme, responded with the pastels on paper, and then gazed at the ways she had utilized elements of art. Finally, she moved to written journaling.

We had a period of time during which participants could share with the group anything that they noticed from their art-journaling prayer. Pamela surprised herself, and us, with her sharing.

> When I looked at the elements of my life, I was not surprised by what I included. What did surprise me was the size of one of the elements. I had used the color red to designate my pain. I had no idea how large it was until I gazed at my drawing. God and I spoke about this in the quiet. I spend a great deal of energy trying to hold at bay the realization of how much pain I have. It is good for me to know. It is a part of my life and I am acting as if it doesn't exist. I am very tired most of the time, and it is the dealing with pain that is wearying. In my regular journal, I hate to whine! I suppose I am careful to write things that sound good. In the art-journaling, I saw something more. Seeing it will not lessen my abilities, but it may help me to be gentler with myself when I find myself in situations that challenge my strength. Fragments of a quotation came to me, "You will find rest for your soul." My soul wants the rest as well as my body, and the rest comes in being honest with my whole self, body, mind, and spirit.

Pamela's story demonstrates how using an art response in conjunction with a writing practice can deepen and alter the insight. When you use the language of art first, you make room for surprise. Jung is quoted as saying, "The hand knows how to solve a riddle with which the intellect struggles in vain."

YOUR PROCESS

When you engage in your own art-journaling meditation, you experience firsthand the relationship between non-verbal journaling and written journaling. This combination enhances your holistic presence and increases your ability to see the inner vision and to hear the inner voice. The linking of image-making and written journaling leads to parables discovered through color and design, and through writing and verbal sharing. Writing helps you to concretize what could otherwise remain an abstract response. It puts your unspoken questions into sharper relief. It helps you to solidify your "holy suspicions" about what is being manifest in your non-verbal journaling. On this path to wisdom, you move back and forth from image

to word, seeing and hearing, gazing and speaking, Eastern and Western traditions. These dualities and their integration are expressions of process.

WHOLE BRAIN APPROACH

Some people come to my workshops announcing that they are "left-brained." They want me to know that doing this right brain activity is foreign to them. I point out that art-journaling is a whole brain activity. You bring to it the manifestation of a developed strength and the energy of an untapped reservoir of ability. You use the non-verbal energy in working with the art material. You gaze. You move back into interpretive, linear reasoning for the journaling. You are open to insight, as well as to deductive reasoning. You combine the best skills to accomplish a journaling that takes into consideration the gamut of ways wisdom manifests itself.

PROCESSING WITH ANOTHER

Sharing the edges of grace with a trusted other can authenticate your inner journeying on yet another level. For instance, art-journaling can be used very productively in a spiritual direction or counseling situation. It demonstrates unique qualities of presence, veracity, and clarity. When you bring your art-journaling into a shared encounter, you engage in the process of creativity itself: a *divine process of calling forth, seeing, naming, and gazing.*

Seeing and naming

Seeing is a dynamic process. It can reveal gradually, or in a swift moment of insight. In its clarifying light, the deception of a judgemental mind is unmasked so that the reality of awe can shine through the experience. In art-journaling, true seeing relies on intuition and deductive reasoning, on inner vision, and on a trained attitude of gazing. The practice of receptive seeing moves the art-journaler away from criticism and toward freedom. The emphasis on being non-judgmental is difficult for adults. It is reinforced as a discipline essential to your development as art-journalers.

In developing practice, you deepen in this contemplative process. You are challenged to gaze, not only on your own visual and written journaling, but also on your life, your history, your environment, and on

all created and uncreated potentials which the Holy flings along your path.

Seeming accidents

If you are willing to pay attention, you might discover process occurring in seeming accidents. In working with colors, someone might say that she/he did not mean to make a certain mark. However, as she/he gazes at that particular mistake, it takes on meaning. An overlay of color appears in an area of life that is currently "murky." A patch of color that is more intense than any other area in the drawing ends up representing a situation of concern. The accidental blending of boundaries happens between two aspects of life that are challenging freedom. I tell people to pay attention to any inkling that emerges from their contemplative gazing. Since this is an unfamiliar language, you probably do not know how to manipulate it. It is hard to trick yourself. It is difficult to express a falsehood through it. I suggest that if you suspect meaning in a seemingly random gesture it is probably the truth. Trust it.

Tricia's story shows the eloquence that can be harbored in careful listening to accidents.

ACCIDENTAL PURPLE

Tricia was a high school teacher who used art-journaling as a tool for prayer. She is aware of her own color vocabulary and associates purple with her search for a more contemplative way of life. She returns to the life-assessment meditations regularly. Recently, she began wondering if it was time for a change in ministry. Her follow-up question to the life-dynamics drawing was, "What does the next step in my journey look like?"

She used the color blue to represent her sense of patience and willing-ness to sustain the ways her life was unfolding. Her confusion, tinged with anger at her indecisiveness, had taken on the color red. Great energy was released when she worked on her journaling and "by accident" these two colors came together. When she gazed, she was startled to see the appearance of the color purple in a prominent place in her art-journaling. The blue and red blended into purple and this accident brought Tricia's thoughts back to her attraction for a contemplative style. Tricia was shaken by the invitation to revisit the question. She accepted the inadvertent

manifestation of an important symbol, and had a renewed sense to keep the possibilities open. A few months later, Tricia heard about a project in which the aspects of her teaching experience and a contemplative stance could blend. It involved preparing young adults for volunteer service, maintaining their community house, and meditating with them. The position-holder would create a space for them to go forth in mission and facilitate their return from a year of service. In embracing this new career, Tricia found a way to integrate her work with an invitation that had haunted her for years.

Process orientation

Do you learn best through process? You are progressing and your visual discernment has broadened. You are attentive to your non-verbal expression and learning more about that unique language. Your written journaling is becoming more precise as you find words to clarify some deeper noticing. You are practicing the difficult discipline of non-judgmental gazing, trying hard not to judge your work, but rather receive it with positive regard. This understanding is filtered through your holistic presence.

In what ways are you fully engaged? You use art materials through bodily gestures. Arm movements describe a sweep of emotion. Small hand movements describe focused detail, and perhaps tension. Your vision and concentration are heightened. Your body-mind and spirit-self is aware of what it means to be doing art-journaling as a human being embodied and inspirited.

Go back to your art-journalings and review them. Record any insights that you receive as you consider them in light of process.

Art-Journaling as product

Revelation is not just all process. There are many concrete images and realities that you encounter; symbols that help you to seek, find, approach, articulate, and emulate this creative *presence.* You are often invited through symbols that are namable, through "products."

Dialoguing with elements in nature

Cynthia recounted an art-journaling experience that arose from a contemplative walk on the beach.

> I spent some of my own quiet time by the sea. I was not consciously working on insight, just hoping to slow down, rest, relax, and become quiet inside. I had just finished a round of chemotherapy treatment. In the open, healing time by the sea, in the presence of creation, something entered into my darkness in a way that manifested edges of hope.

> As I walked along the shore in the early hours, I noticed an array of conch shells scattered along the sand. I was most attracted to ones that were broken or eroded. The wearing away gave me a peek at their inner structure and revealed their beautiful spiral design in a way that I had never seen. I picked one up and brought it back to my room. During those days of simple relaxation, the conch shell continued to speak to me about the beauty found in the slow process of wearing away, about the patience I must have with the life-process, about the mystery of brokenness, and the capacity of brokenness to transform.

Figure 3.1 This pen and ink drawing echoes the intricate beauty found in nature's shapes and spaces

This describes a creative process of art-journaling. Cynthia shares her contemplative gazing, noticing an element in nature. She allows the qualities of that element to reveal something new, or to confirm something suspected. Here was a way for Cynthia to be with a product (the shell), to engage in a process (noticing and naming), and to maintain a non-judgmental presence (gazing) to the imperfection of the shell. That stance allowed her to receive from its universal wisdom and beauty, and to identify that same wisdom and beauty in her own life process.

Clay as product prayer

A frequent theme for me as I enter into prayer time using clay begins with the phrase, "What is the shape of?" I put the question before the Holy and probe the shape of my emptiness, or receptivity, or holding. Although I am aware of the process of forming, my reflection becomes concentrated on the product, the shape of the vessel. The sculpture always tells me something about my openness, my fragility, my strength, my withholding, or whatever other qualities are reflected in the work. I have a series of vessels and they speak with eloquence about my own history of spirituality when I view them as a group. They reveal glimpses of inner wisdom at junctures in the journey.

Figure 3.2 An art-journaler gathered her clay vessels, gazing at them together to notice any emerging themes, progressions, or relationships

Leading images

There are times when you can rest in the concreteness of the product aspect of your spiritual life. Images and solid places that are describable bring a momentary relief in the vast desert of that which is only barely perceivable.

The word *product* comes from the Latin derivative *ducere* – to lead. A way of thinking about product (*pro ducere*) is to consider that it leads you forward along the edges of grace to revelation. Living with this product can lead forward. Once you do art-journaling, the image remains. Tomorrow, your art-journaling may say more to you than it did today. Sometimes you need to be patient and wait for the parable to evolve.

Products of art-journaling

In the prayer of art-journaling, how do we experience product?

1. In the visible result.
2. In the action stemming from the insights in the art-journaling prayer.
3. In the presence of design elements.

Visible result

In art-journaling, the product is the result of the activity. It is the clay pot, the series of decision-drawings, and the eroded shell. I learn from product when I look and see something startling or confirming. I see a patch of intense color in the area I designated as a particular relationship, and I begin to probe the reason for the intensity. In process, I notice that two of the colors in my latest journaling now interact and make a third. This third color has been my past symbol for solitude. It now exists in the product of my work. I am challenged by this teasing possibility and spend some time with its possible invitation. Working with art-journaling is like working with a dream. You are the interpreter. You play with meanings and possibilities, holding them up to your history, your experience, and your wisdom.

When you engage in art-journaling, you produce a visual statement. The product of the art-journaling appears on the paper, emerges from the clay, or flashes in your mind's eye. It is the image that your mind tries to

decipher. It is a mass of unrelated lines. It is also the reflective writing that clarifies these visual statements. You describe it to yourself and see what else you hear. This product of art-journaling reveals a language that expresses both an immediate and an ongoing communication. This language can continue to speak to you, revealing in the moment and over time.

Action

Another eventual product may be the action that you take based on insights that arise from art-journaling. What happens in your life as a result of what you learned becomes a describable product. Perhaps it is a choice, a decision to lead a healthier life, or a call toward more contemplation. Actions, resolutions, sighs of relief, waves of humor can also be products of your art-journaling. Insights that move you, subtle realizations, reconciliations, integrations first happen in the work, are noticed there, and become translated into your everyday life. Tricia decided to move toward a more contemplative lifestyle. Another art-journaler sees the need to create more space in her life, and does just that. A young student signs up for an extended retreat after visually encountering his resistance to a vocational invitation. A woman who was having difficulty with a co-worker reaches out to her after prayerfully visualizing the space between them and discovering grace. These decisions are products of art-journaling.

The next products to consider are the amazing creatures that make up the landscape of design – the art elements. They are the building blocks of an intricate language with which we are familiar. Let us spend some time in their company.

4

Design Elements
and the Language of Art

The speech of vision

Look, and you find them everywhere: lines, colors, and shapes. They are common and eloquent, mysterious, atmospheric, boring and ordinary, consistent, stoic, eccentric, unstable, and profound. They are the elements of design in art. They are your intimate companions on the journey and they effect and affect everything within, among, and around you.

In the life-elements meditation you responded to the question, "What are all the elements that make up my life as it is today?"

To answer this, you probably needed to include such things as people, relationships, ministry, job, skills, feelings, wonderings, hopes, desires, pains, sorrows, losses, worries, gifts and liabilities, limitations, wounds, places of wonder, and movements of delight. You were able to symbolically express these aspects by making marks on paper. You engaged in a visual language as the way to concretize and answer this question. The building blocks of the language you used are the elements of design: *line, shape, form, color, value, texture,* and *space* (Crystal Productions 1996a, 1996b).

Encountering artistic elements

Art students come to the study of design elements in art to obtain a better understanding of contemporary and historical art movements. They come to enhance their vision, and to learn ways to craft a balanced design, a harmonious painting, a unified print, a textured sculpture.

As an art-journaler, on the other hand, you come to the study of the design elements in order to decipher something that you have already made visible. By identifying these elements in your art-journaling, you

gain specific visual sensitivity. Communicating through this non-verbal language leads you to spontaneous, as well as informed, wisdom. Through enhancing that wisdom, you prepare to hear with clarity the spoken and unspoken word of creativity.

Up until now, you have been doing art-journaling exercises, and then gazing at the finished product in order to notice which elements speak to you. This intuitive sense allows your hunches to coalesce. Now you meet the design elements in their own natural habitat, and get to know each one individually.

I believe that getting to know the elements of design will help you immeasurably in reading your own art-journaling. It will give you a completely different way of understanding what you are saying to yourself when you work with art materials. Practice will help you grow flexible in employing these design tools. You use them all the time, but might never be conscious of the quality of a particular line or the significance of a color. When you become aware, you will be amazed at the congruency of this artistic language and the language of your inner spirit.

Seeing and exploring

Spend time acquainting yourself with art-element definitions. Heighten your ability to recognize their appearance in your work. Familiarity with the elements of design will enable you to play with them in a more intentional way.

Included after each introduction to a design element are suggested ways of seeing and utilizing it. Attempt some suggestions and come back to others. You can create added ways of engaging each design element as it becomes timely.

Marks

The elements of design are marks and the areas between those marks. When you make a mark in a reflective way on a blank piece of paper you have begun your art journaling. When you push your thumb into a chunk of clay, you embark on expression. A mark gives your work visibility. Even the smallest mark on the face of a smooth surface has significance and consequence.

Seeing marks

Look contemplatively for and at marks in the world around you. Far away, find stars in the night sky. Close up, discover points of color in flowers before they open. Grains of sand are tiny points making up a vast landscape. The complex marks made by the scurrying of small birds across the sand alter the landscape. Spend some time meditatively searching your corner of the universe for marks. Rest in the lessons they are waiting to teach you.

Formal elements of design in art

You are being introduced to the elements of design as they are presented in *Elements and Principles of Design Posters: Teacher's Guide* (Crystal Productions 1996a). This workbook and its art posters have been resources for many art students and you are now among them. Using the categories in this source simplifies and concentrates your learning. In other books dealing with design theory, you may find the elements listed differently. *Design Language* by Tim McCreight and *The Creative Artist* by Nita Leland are two of many books that deal with design in unique ways. An array of wonderful design theory books is available whenever you want to delve further into this fascinating study.

Meeting and greeting

Meeting art elements can be such an adventure. Exploring them can lead you down untrodden paths. They are like neighbors in the apartment building of life. You have been living side by side, but some chance encounter suddenly reveals to you how intriguing they have been all this time.

I had the pleasure of making the acquaintance of design elements when I was a teenager. The art assignments I had to do in high school about line and color are still vivid in my mind. We were supplied with a pack of brilliantly colored papers and every night for several weeks were sent home with a design statement. "A small light spot dominates over a large dark area." "A large rectangular shape will balance a small irregular shape." The homework was simple: demonstrate the truth of the statement by cutting out and arranging colored shapes on a full sheet of paper. It was mesmerizing work and it built up my understanding of the

underlay beneath visual realities in the way nothing else ever has. Matisse, in his later life, used cutouts and arranged them into some of his major works. You may want to try this medium with some of the design exercises. Watch the ways that shape, line, and color relationships change under your hands. Cut out textures and patterns from magazines. Move elements around. Think about how you might also do that with the elements of your dynamic life.

Do not let the allure of cut paper keep you from using pastels, pencil, or clay for some of the other suggestions. Notice which materials yield the best information for you.

Line

Line is a mark made by a pointed tool, a brush, pencil, stick, pen, etc. It is often defined as a moving dot. It has length and width, but its width is very small compared with its length. A line is created by the movement of a tool and pigment, and often suggests movement in a drawing or painting.

In design theory, one learns that a line results from a point being put in motion. We can create straight motion, curved motion, or angular motion. A line is a point that travels vertically, horizontally, diagonally, or in a circular motion. It even travels at various rates of speed.

Line can possess weight, tone, and texture. Line divides space and gives outline to form. Line defines contour or gesture, gives structure and may be descriptive or decorative.

"Lines may be thick, thin, fast, slow, serene, agitated, jagged, lyrical, and aggressive. Line brings energy to the design."(Leland 1990, p.58).

Line is very ancient. Primitive people used line in their cave drawings and to indicate symbols. Babies use line in their first scribbling ventures. Young children use line when learning to draw letters of the alphabet. Line is the most primary, the most direct, and the oldest method of creating visual expressions. Line in its most familiar form occurs as a combination of all these basic types; you call this calligraphic line handwriting (Cheatham, Cheatham, and Haler 1983 p.119).

Seeing line

Begin to notice the element of line in the world around you. Does it seem to exist by itself? How do lines in nature affect you? Look at winter branches, at curved lines in leaves or flowers, at agonized lines of twisted vines. What else are you seeing?

Figure 4.1 Wonderful lines in tree branches and the leaning fence are evident in this photograph. Texture, space, and value are other design elements that speak to the gazer

Can you notice line in your own art-journaling? What are the qualities of line that speak to you? What are you expressing through your use of line?

When you look at works of art, can you notice the lines that are employed in the design and begin to receive something of their expressive quality?

Do you know about Lascaux or Newgrange? These are prehistoric sites where drawn and sculpted lines have been discovered. In the caves at Lascaux are wonderful animals, depicted in the colors of earth pigments. They chronicle the ordinary lives of our ancestors. At the entrance to the Newgrange passageway is the mysterious triple spiral carved into the

rock. The lines describe infinity and speak in a timeless way to our intuition and our hope.

In your imagination, go periodically into the cave of your life. Draw on the walls. Use lines to bring forth whatever things play an essential part in your existence. Use earth tones, the colors of the ground of your days. Go there often. After you draw, lie down on the floor of the cave and view in the half-light those magical and mystical presences. Sleep with the visions and allow them to expand and transform.

Exploring line

Use line to trace your spiritual lifeline, indicating the highs and lows, the thick or thin, broken, curved line quality that speaks of your history of spiritual awareness. After you create this unique line, gaze on it and do some written journaling to clarify the stories you find there.

On an empty piece of paper, make a random line. Spend some time in quiet, listening for whatever that small action wants to reveal to you. Or, pray to understand the feeling level being expressed on that line on your paper. Does it signify loneliness, power, or whimsy? Do some written journaling to focus this expression.

Create a meandering line on a piece of paper. Contrast that with a definite line. Vary the thickness of each line and explore the aspects of communication in line. Imitate, but do not use, writing and create the look of a language using line and space.

Reflect in writing on the visual experience.

Shape

Shape is an area that is confined within an implied line, or is seen and identified because of color or value changes. Shapes have two dimensions, length and width, and can be geometric or free form. Design in painting is basically the planned arrangement of shapes in a work of art.

A shape is an area defined by boundaries that separate it from other areas and/or from its surroundings. Anything visible has a shape that provides the main identification in our perception. Ordinarily, the word "shape" is used to describe something two-dimensional. When searching for shape, you may identify several different categories. Shapes can be *geometric*: squares, circles, and triangles. Shapes can be *organic*: described

by free-flowing curves. In visual art forms, organic shapes frequently reflect nature. Another general category can be called *accidental.* These are created either in an unplanned manner or they might be the result of intentionally using a material that cannot be controlled completely. I can intentionally spatter ink or throw paint at a canvas and create accidental shapes. In art-journaling, even accidental shapes can reveal important insights.

We arrange shapes, whether these shapes be realistic or abstract, geometric or organic, to design a composition. "The shape of an object is a positive shape. The background or the spaces between shapes are negative shapes." (Leland 1990, p.58).

Seeing shape

Sometimes, there is a discrepancy between what I think something looks like and how it actually appears. In my memory, a rose has rounded petals. When I gaze on it without preconception, I see that this particular rose consists of shapes that look square or angled. The soft, rounded petals of my expectation are not there at all.

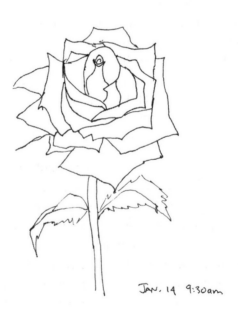

Jan. 14 9:30am

Figure 4.2 Pen and ink drawing representing shape: we see angular petals making up this particular rose rather than the soft, rounded shapes that our memory and imagination might expect

Look at the faces of people you know and mentally begin tracing the shape that you are really seeing. Look especially at faces in half-light and trace the shapes of the shadow. It is frequently the shape of the shadow that lends shape to an object.

Look at the shape that sunlight makes on the ground when it is filtered through trees. Look at the shape of the shadow cast by a bowl of fruit, or by your favorite plant. Look at the real shape of a shell, especially its inner space. Enter into shapes. Let shapes lead you. Let shapes stop you in your tracks.

What shapes are most pleasing to you? What shapes do you regularly use in your home design, in the patterns of your clothing? Where else does shape affect you in your everyday life?

Exploring shape

Use simple shapes to represent those people with whom you interact in the varying roles of your life. Look at the space between these shapes, as well as the way they may or may not relate to each other. Gaze and receive in a contemplative way. Do some written journaling to help clarify the expression.

What are the shapes of your core choices, your non-negotiables? Draw these shapes. Gaze at the composition. Do some written journaling.

Do several art-journaling sketches, playing with the compositions of the major and minor shapes in your life. Is there any need to adjust these shapes to create a balanced, harmonious, artful composition of this time in your journey? Invite Wisdom to illumine glimpses of the parable hidden in these compositions.

Cut out shapes and move them around on a piece of colored paper.

You can learn to be attentive to the shapes between things, around things, within things. What is the shape between the leaves on a plant or tree? What is the shape of the space between you and a particular person?

Form

Form describes volume and mass or the three-dimensional aspects of objects that take up space. Forms can and should be viewed from many

angles. When you hold a baseball, shoe, or small sculpture, you are aware of their curves, angles, indentations, and edges – their forms.

When dealing with sculpture, with its three-dimensional mass and volume, we refer to its "form." Sculpture can have geometric form, square, cubistic, and straight-edged. Organic forms are rounded, flowing, undulating. Abstract forms simplify forms to their basic characteristics. Non-objective forms do not represent any natural forms at all. Realistic forms depict people, animals, and plants as they might actually appear (Crystal Productions 1996a, p.8).

Seeing form

We see form in the three-dimensionality of things. Spend some time walking around objects in nature. See how the sun and shade creates roundness or planes in objects as you approach them.

See shapes in humanity: the diversity demonstrated in the human form as it traverses the earth every day.

Gaze at an arrangement of fruit on a table or a bunch of flowers in a vase. View these from multiple perspectives. See how the forms interact to create forms within forms.

Exploring form

Work with clay. Make impressions in the surface of the material. Gaze from all sides at the form that emerges. Continue to alter the form by making small adjustments to the shape in your hands. Put it in a light source so that you can observe the play of light and dark. Think about the aspects of your own life that exhibit the back and forth of light and shadow. Take a walk outside and observe the changes that occur in form as the shadows change. Notice or draw the changes in a tree, a rock, a house, a shadow.

What is the form of wholeness, of loneliness, of hope? Use clay to help concretize these qualities and do some written journaling based on your gazing at the form from a variety of perspectives.

What is the interior form of your fear, your delight, your hope, or your stubbornness? Image those forms. Name them. Gaze and receive. Do some written journaling to help clarify this meditation.

Color

How can we define color? We can say that a shape is distinguished from its surroundings because of color. We can say that perception of color is the most strongly emotional part of the visual process. We can name certain properties of color. Beyond that, we can only marvel at this rich, visual ocean and the ebb and flow of color's role in our existence.

The three primary colors are red, blue, and yellow. They are primary because they cannot be mixed by combining any other colors. Mixing red and yellow makes orange. Mixing red and blue makes purple, and mixing blue and yellow makes green.

A complement is a color's opposite. Red and green are complementary colors; they are opposites. When opposites are placed side by side, they create a "visual vibration." Blue and orange are complements; yellow and purple are complements.

When all three primaries are mixed together, brown results. Color in its broadest sense comprises not only all the hues of the spectrum, but also the neutrals: black, white, and all the intermediate grays.

Color depends on light because it is made of light. There must be light for us to see color. A red shirt will not look red in the dark where there is no light. The whiter the light, the more true the colors will be. A yellow light on a full color painting will change the appearance of all the colors.

In the visual arts, color has three properties. The first is *hue*, which is the name of the color, what is seen in the spectrum. The second property of color is *value*, which refers to the lightness or darkness of a hue. The third property is *intensity*, which refers to the purity of the hue. Many of the attributes of color speak to us at the level of our intuition. Color has great emotional content and usually a long intimate history for individuals. We frequently hear people make such statements as, "I hate green, but I love turquoise," "I always feel formal when I wear black," or "Orange makes me anxious."

Color and its properties: hue, value, and intensity, can interface with our life of grace, our desolation, transformation, and dark night experiences. They can tinge with meaning the hues of overwhelming sorrow, joy, grief, and confusion. They can symbolize for us resurrection, liturgical seasons, healing, and other aspects of metaphoric life.

Seeing color

Locate intense colors in a landscape. Where are they?

Begin looking at blacks of shadows and whites of clouds to discern the tiny hints of hue.

Look at vegetables and see the many manifestations of color there. See how the presence of light affects the transparent colors of growing things: weeds, plants, even your own skin. Look at the colors in a tree branch. Find intense and subtle colors in seeds and fruits.

As you drive along a highway, notice the colors shining forth in the layers of rock or soil. Construction and erosion reveal the hidden treasure of umbers, siennas, and ochres. Look deeply at fabrics. Even the simple black and white of newspapers harbor subtle colorations when you gaze at them anew.

Exploring color

Image with color those areas in your life in which you experience intensity. Identify the places in your life in which you sense pure color and dull color. Image those places that need to become lighter, those areas that need to become darker.

The property of hue is the name of the color. What are those places, aspects of your larger life in the environment and in the community, that you know by name? In prayer, image those places and notice the colors of clarity that emerge. Challenge yourself to do an art-journaling, probing the details of this theme.

What are the colors that express the history of coming to know your "hue," your "true name?" What colors help you to touch the mystery of significant others, or of a particular situation? In the presence of the Holy, allow all the properties of color to help you express this knowing. As you gaze on these colors, allow the intensity and value to speak. Do some written journaling to bring the experience to clarity.

Cut out lots of pieces of color. Place them in different arrangements on colored paper, white paper, and black paper.

Value

Value refers to dark and light. Value contrasts help us to see and understand a two-dimensional work of art. This type can be read because of the

contrast of dark letters and light paper. Value contrast is also evident in colors, which enables us to read shapes in paintings. It is the darkness and lightness of a hue, the amount of light reflected or transmitted by the object. It is a particular color's relative brightness. Any hue can vary in value. Grays, as well as colors, exhibit value. Value is expressed in a range from white through grays to deep black. Value is synonymous with brilliance and luminosity (Crystal Productions 1996a).

Value changes help us "feel" the shape of an object by showing us how light illuminates these forms and creates shadows on them. The entire object may be the same color, but varying amounts of light give it different values.

Seeing value

Look into the distance in a landscape and notice the value changes caused by light and space. Look at rounded objects in daylight and in interior spaces. Trace how the values of a single color change in relationship to light sources on a curved surface. Squint!

Figure 4.3 Photographic example of value. We gaze and notice darks and lights and the transitions from one to another

Dawn and twilight are value times in the day. See values move through darkness to light from sunset through dawn. Study a candle or light source in a dark room. See how the expression of light value moves out from that place interacting with the surrounding blackness. Be stunned by the glow of Moon in the darkness and her reflection in the shimmering river below.

Exploring value

Cut out pieces of black and white paper and arrange them on a background. Create the transitions between them with other pieces of colored paper or by utilizing a lead pencil or pastel, and making each gray a bit darker. Locate your sense of life transition on this scale of dark to light.

Think about the places in your life that you might refer to as the "gray areas."

Texture

Texture refers to the surface quality, both simulated and actual, of artwork. Techniques used in painting serve to show texture. A person can use paint on a dry brush in a technique that produces a rough, simulated quality. She/he can use a heavy application of pigment with a brush, or other implement, to produce a rough, actual quality and the paint stands out from the surface of the canvas (Crystal Productions 1996a).

The characteristic of texture may be plain or decorated, sleek or jagged, and may appeal to the sense of touch as much as to sight. Texture can appear to be rough or smooth, or it can actually be rough or smooth to the touch. The surface can be coarse or glossy, soft or hard. Texture can be used in a drawing to represent a known surface, or textures may be invented to serve the drawing in an abstract way. The use of texture changes the feel of a shape, adding complexity to an otherwise simple form.

Seeing texture

Cloth provides wonderful aspects of texture. Notice the subtle and the nubby, the soft and rough textures of cloth with which you come in contact.

Your skin has texture. Look at your hands, your knees, and the soles of your feet. See the varieties of texture that appear on these different body parts.

Look from the texture in a child's face to the face of an adult. What are the similarities and differences in these textures?

What is the texture of plastic bags and paper bags? How do I distinguish the qualities of texture?

Walk through any grocery store, mindful of textures. Look at tree trunks and notice the wide variety of texture there. See how the context of a tree's environment provides delightfully contrasting textures.

Figure 4.4 We encounter texture in the tree bark, the ground and the distant leaves, but are also shown space, value, and a strong line presence in the fence and in delicate smaller branches

Exploring texture

What does the texture of grace in your life today look like? What is the texture of the different eras in your life: childhood, adolescence, and adulthood? Can you image the texture of your experience of desolation, and/or of consolation?

In a discernment situation, try to image the textures of each of the options. Spend some time seeking out similarities and differences. Does that information add anything to the clarity of the discernment process?

Cut out papers from a magazine that exhibit texture. Collect textured things in nature. Pray with the manifestation of a variety of textures and your experience of the main activities in which you are involved.

Space

Actual space is a three-dimensional volume that can be empty or filled with objects. It has width, height, and depth. Space that appears three-dimensional in a painting is an illusion that creates a feeling of actual depth. Various techniques can be used to show such visual depth or space.

Space can be defined as the distance, interval, or area between, around, and within things. Space can be occupied or left blank. It is relational. All visual expressions incorporate shallow, flat, illusory, or actual space, either individually or in a variety of combinations (Crystal Productions 1996b).

Look ahead at Figure 8.2 (p.140), as well as at your own art-journalings to notice the expressive power of space.

Seeing space

Looking and sensing space can be one of the most contemplative aspects of art elements. Seek out tiny spaces between the reed weavings of a basket or the leaves in a plant. Then shift your gaze to out of a window and let that space penetrate you.

Stand very still on a beach and gaze down to the ground beneath you. Experience the space between your gaze and the earth. Now, swoop that gaze upward to the horizon, and pause there, noticing what expands and what contracts around and inside you. Again, move your gazing to the sky, and continue to let space open up before you and within you.

Stand in a flat field and visually relate to the horizon.

Be in a city and notice perspective space. Look down a line of telephone polls. Let your eye slowly move along the railroad tracks as they recede into the distance. Travel pathways of space.

Look at your face in a mirror. What is the quality of space between you and the image before you?

Figure 4.5 Our vision is drawn into the "small silences between the leaves" (Moffitt, cited in Dunning, Lueders and Smith 1966, p.21)

Exploring space

What is the shape of the space that creates receptivity in you? What is the shape of the space in between your goals and realities? Where does perspective space exist in your life, and into what reality does it invite you? Where do you experience icon-space? Where is your space most crowded, most open, most empty?

Use the element of space to show something about how you are living your life in the everyday demands of your work.

Notice which question calls out to you. Answer the question using pastels and the art elements. Gaze on your response and also notice how you are feeling in your own interior space, the place of your inner knowing. Do any written journaling that will help you to focus this prayer.

Size

Size is an attribute that can relate to all of the art elements. Size tells us how big and how small something is. It has to do with how much space a thing occupies. Related to size are the elements of scale and proportion. *Scale* denotes the size of people or objects in relation to their environment. It is relative if described in terms of bigness and smallness, but it is also physically measurable. *Proportion* refers to the size relationship of all parts to a whole. In abstract design, size relationships determine the visual impact of shapes and colors.

Seeing size

Trick your eyes. Look at something and imagine it in a huge landscape, or in a small landscape, and see how your perception of size alters a thing. I remember seeing a photograph of a Henry Moore sculpture before the foundry translated it into mammoth proportions. It was tiny and ordinary. I was amazed at how different I felt about it. Even though it exhibited all of the curves and angles I loved about his work, seeing it small changed everything in my perception of its nature.

See a stone as a small pebble and then see that same stone as a huge rock. See how your senses change around that perception.

Exploring size

Use the shape and size of the paper that you choose to hold the proportion of the prayer questions on size.

Identify some aspect of your current life and think of it in terms of size. How big or how small is it in relationship to the totality of your concern?

Identify elements of your life that are of value to you. How big are they in relation to the rest of your activity? Any need for adjustment?

How large is your pain or your hope? In what proportion do your leisure, your ministry, your family, your visions appear in relationship to each other?

What is the size of your relationships, your work, your rest, your contemplation?

How do you notice size in your drawing? How do you make comparisons? What do these comparisons tell you? How large is time for yourself?

When looking at the elements of your life, what elements have you rendered the largest, which the smallest?

After rendering these in art-journaling according to the amount or proportion of space they occupy, do some contemplative gazing and then complete the prayer exercise with written journaling.

Content as product

Content is an interpretation. It is the result of a gathering of art elements. Content in art-journaling is the totality of meaning that the mind assigns to some random and intentional marks on the paper. When a person gathers certain shapes and colors in an organized pattern, the mind identifies "face." This might be identified as the content of a particular art-journaling. However, it is important for us as art-journalers not to be captured by the content of our art-journaling. A person may begin to answer the question, "What does my life of prayer look like?" The end result might resemble a plant. If we rest in content only, we might bypass the art elements and think about the wonderful symbolism of a plant, green, rooted, healthy, strong, and growing. And so, going "underneath" content, we look at the lines that went into forming this plant. We look at its color, shape, size, and space to receive a deeper understanding of the response made to this art journaling.

Gazing at fine art

When I go to an art gallery, certain art pieces get my attention. They are not always the same works. I might not even "like" those that hold fascination. Something in the painting is speaking to me, either in congruency, in invitation, in challenge, or even in repulsion. Sometimes, when I am in turmoil, it is a relief to see my own inner confusion or pain externalized. I can find myself drawn to a painting or sculpture that is tortured, one that displays little obvious beauty or relief. Sometimes I am drawn toward harmony and beauty in order to shift my feeling of inner turmoil.

In looking at art, often we seek out what we need and where we would like to be, looking toward visual expressions that display a more peaceful atmosphere, or that possess great beauty. Sometimes we rest in a congruent harmony and allow that to deepen through our visual

receptivity. Sometimes we look for an externalization of feelings that are unable to be acknowledged in consciousness, let alone in words. This spectrum of feelings is expressed through the artist's use of design elements. As we become more visually sensitive, we can read the parables of this language.

As art-journalers, you will continue to consider these design elements, because they are an integral part of this method of creative prayer. You will give a different kind of attention to these powerful ways of communicating, in order to be present to your visual expression with knowledge and intuition.

Art-Journaling
A Way of Presence

The creative eye

What is the quality of presence that you bring to your practice of art-journaling? And what do I mean by presence?

Presence includes the act of seeing, your willingness to gaze, and your attempts at letting go of negative judgments. Careful tending of your way of presence allows inner vision to break through and point to deeper meanings. Presence helps you to cherish rather than to judge. Presence defines the edges of contemplative practice and invites you forward.

From the first moment you ventured into this journaling process, creative seeing has been an essential provision for your inner journeying. For some travelers, maintaining this way of presence constitutes the greatest challenge to the practice of art-journaling.

Seeing heals

I am always taken aback by the frequency and depth of the injuries people have sustained around their creativity. I hear far too many stories from adults about their childhood encounters with art in school. Despite earnest attempts, some young students were told that their artwork was not right. Their efforts were belittled as not good enough. They were categorized as lacking that elusive quality of talent. Many people I work with carry this burden. These experiences, still recounted with amazing clarity years later, all but closed the door on any future openness to art. Given this background, it is easy to understand why some adults have difficulty maintaining a non-judgmental stance in relationship to their own art-journaling. It stands to reason that my direction "to gaze lovingly at

your work and receive from it" encounters a skeptical response from the most willing of participants.

The quality of presence that you bring to your practice of art-journaling is integral to the discipline. You are exhorted to gaze on your visual response, to pause in contemplation before proceeding to the written journaling. At each turn along the art-journaling path, you are directed to return to intentional seeing. How successful have you been in doing it?

Reclaiming sight

When you were a child, you had new experiences every day. Learning the unfamiliar was part of the adventure. In this grown-up life, you move into experiences that are familiar, gaining expertise in arenas that are specialized. There is nothing wrong with this. It is the way we develop into competent adults, expert workers.

Becoming an adult includes moving toward areas of mastery. As you mature, you have less frequent encounters with elements outside of the sphere of your chosen field. You strengthen your areas of interest, building up whatever it is you do best. You gain focused experience. This seems to be a natural flow in education and professional growth.

Somewhere along the way, you also develop critical thinking. This is not a bad thing in itself. It helps you to make fine distinctions and good decisions. You cultivate it as an aspect of maturity. The unwelcome byproduct of this maturing tool can be an internalized judgmental stance. This skill, which helps you in other arenas, gets in the way of your innate ability to gaze at your own life with creativity and compassion. You use this tool to cast a critical glance at yourself. From that glance forward, you never quite measure up.

Based on this model for maturity, practicing a "way of presence" in art-journaling becomes even more significant. You must reclaim the vision you had in a simpler season of life. The restoration of creative gazing as a habitual way of acting can be the most challenging aspect of the art-journaling process. It can also be the most rewarding. Non-judgmental seeing is an ointment for the pain of the past. It is a way to move forward through healing into freedom.

Learning anew

So, in your art-journaling practice, you spend time relearning contemplative gazing and receptive seeing. What will be the best teacher? You will learn to see again by developing your visual sensitivity, by gazing in a contemplative way at nature, and by searching out the unique faces of humanity. Your most eloquent learning, however, might be in going back to the experiences of a child, recapturing the direct gift that was yours in the beginning.

Gazing

Did you ever spend time with a baby, seeing the child see, experiencing that child as he or she gets to know your face? You can understand a bit of that intense and open gazing as you recall that precious moment, being the object of sight for a fresh new life. Children look in wonder; they gaze and they explore with their eyes and senses together. When was the last time you were the subject of a child's gaze? With studied stare, she probes your eyes and every feature, looking and touching. There is nothing to compare with the joy of receiving that rapt attention. The little one projects no judgment, only curiosity born of the purest desire to know. Watch a toddler squat down and finger a rock, touching it and rolling it around to see it on every side. Can this singleness of focus, of intent, of wonder tell you something about contemplative gazing?

You tap that quality of seeing when you draw and write with compassion while "visually listening" to an inner knowing revealed through your art-journaling. You practice letting go; you surrender being the expert. In practicing this way of presence, you stretch your horizons, gaining access not just to the wisdom and beauty within, but to the wisdom and beauty of our world.

When you practice contemplative gazing, besides risking the pain that comes with the beginning of transformation, you risk joy. You enter into a contract with delight. With Cynthia, you gaze at the eroded shell and are held in that universal confidence called hope. Do you recall Phillip's story of the *Seeker*? In visually listening to the skin of the clay statue, he heard significant truths about the skin of his own mysterious humanity. What Cynthia and Phillip received was not just for them, but also for the transformation of the human family. This is equally true for

your own experiences of insightful gazing. Engaging in art-journaling launches you into a way of presence that illumines inner grace. Like all spiritual practice, it is a window into the mystery of divine wisdom hidden and manifested in the created and uncreated world.

Receptive seeing

You are constantly receiving information from the visual. The intensity of the things that surround you makes it harder and harder to see with awareness. You are bombarded by visual stimuli and have learned ways of filtering so that you can survive driving on a freeway, walking through a shopping mall, or watching commercials on television. In a delicate balance, you are invited to become more discerning with the filters. It is important to maintain protection in situations of visual overload, but it is equally important for your soul to rest in moments of parable grace. To see the manifestation of wisdom shining through, you must develop the flexibility to enter into receptive seeing at the times of your choosing.

In the anthology *Reflections on the Gift of a Watermelon Pickle* (Dunning, Lueders and Smith 1966), I came across a poem by John Moffitt entitled, "To Look at Anything". In it he invites us to know a growing thing by entering into the "small silences between the leaves."

This is an apt description of receptive seeing. You gaze at a growing thing. Your eyes caress it and, in the caressing, you find a small emptiness. Your gaze rests there and the silence and peace held in that place emerges and you receive it. The poet captures this essence as he invites us to "Be the thing you see" (Dunning *et al.* 1966, p.21).

Receptive seeing will always hold out the possibility of surprise. You engage in receptive seeing when you look at your own art-journaling and allow a pause for the colors, shapes, and lines to tell you more. You receive from the place of murky color and you enter into the silence there, wondering if this patch wants to speak. You engage in receptive seeing when you look at someone you know very well and, for a moment, decide to shift to an open stance. Perhaps then you view this person anew, someone beyond your already formed opinion. You engage in receptive seeing when you allow the circumstances of your life to speak to you. You notice the movement in your life and pause to allow this movement to teach you something of how your life is evolving, of where your true

values are manifesting, of what needs to increase, and what needs to decrease in your life in order for you to be more authentic.

Over the years I have had the privilege of attending several workshops led by Frederick Franck. I first met him through his book *The Zen Of Seeing*. Then, one autumn Saturday, I found myself in his presence within a circle of people armed with .05 Pentel pencils, white paper, silence, and creation. We spent the day using the tiny point of lead to contact and encounter lettuce and ferns, rocks and the human hand. I left with an easy familiarity with the voice of the leaves that I met in the silent seeing. Several years later in his "Life Drawing Life Workshop", I spent days contouring the lines of the human body, all sizes and shapes, encountering the heart of living uniqueness. I go back to these memories, finding the confidence that only experience can yield. These, and a lifetime of meditative art encounters, form the backdrop of my conviction that the stroke of pastel, or the push into clay, when done with trust and attention, will invariably lead you to places of truth. You will meet *Wisdom* in these places long before you can encounter her in other more conventional ways.

Parable-seeing

Parable-seeing is a core practice in the art-journaling process. You participate in this way of seeing and learning when you gaze, notice, and hear the story within the encounter. Parable-seeing positions you to receive the wisdom inherent in all aspects of nature, in the leaves and in the silence between the leaves, in the lettuce, the fern, and the eroded shell. Each of these organic presences has a parable to hold up to your life experience.

You are also led to parable-seeing through the symbolic messages carried by the elements of design in your art-journaling expressions. Parables are part of world literature. In the Christian scriptures, they are a significant genre used for teaching. Jesus as teacher spent a great deal of time with his followers, inviting them to gaze and to learn from that gazing. The invitation of Jesus to "Consider the lilies" is a way to prayerfully engage in parable-seeing.

Visual metaphors learned by prayerful gazing are a call to sacred seeing. These are abundant in the mystical literature of all spiritual traditions. They greet you in medieval tomes and modern poetry. The poet and prophet invites, and you imagine following his gaze to a field of growing flowers. He becomes silent, allowing you to make the connection between the flourishing flower and your own life. He asks you to consider, to see, and to learn. Mystery, as well as reassurance, is revealed through nature if you have eyes to see. This is a continual message as he gives profound clues: "Look at the seed...," "Consider the birds of the air..." When you are invited to undertake parable-seeing, you are encouraged to learn from the visual. You gaze and allow the growing of a seed to teach you sacred truths about all of life. That same sensitivity to parable-seeing can be applied to our art-journaling. After we respond to a question using a broken line, or an angled shape, or an intense color, we spend some time gazing. We treat each of these elements as a parable and ask questions: for example, "What does the quality of a broken line tell me in relationship to my theme?"

We expand our noticing. We see the natural world, we gaze at the faces of people around us, and we identify the elements of design in our art-journaling prayer. This contemplative noticing sharpens our sight for making distinctions.

Like the scriptural invitation to consider the lilies, art-journaling challenges us to a deeper reflection through visual experience. The discipline of art-journaling enables the elements of design that are present in the lily, in the flight of a bird, in a sculpture, or in a painting to become a parable for us.

Underneath the image

Utilizing parable-seeing with art-journaling unlocks wisdom hidden in the language of art and in the elements of design. We are looking first to identify, to name the art elements. Then, we learn to look through these. We look through line, shape, perspective, and texture for the parables that are waiting for us there. We enter into space so that the space of our gazing may become revelation. We are engaged in parable-seeing; we are held in icon-space.

Icon-space

You have come to recognize space as a design element. Space, as an essential expression of art traditions, also has had evolving significance in the history of art. The ancient caves of prehistory, lined with the drawings of humans and animals, are canvases depicting shallow space. These walls hold images of great power expressing vitality, mystery, and movement. The renderings exist in their immediacy with no indication of space opening up in front of or behind them.

A much different experience of space occurs with perspective drawing. In the Renaissance, artists learned how to arrange visual space to imitate depth. Through inventive and mathematical ways, the artists of this era created wonderful landscapes and architectural settings so realistic that the viewer is invited to wander into the scene itself, to get to know the personalities and the details depicted.

A distinctive use of space occurs in the icon or Byzantine tradition. "Byzantine space opens outward and downward into the real space before it and below it in which the onlooker stands" (Matthews 1963, p.34).

Icon-space is very different from the dynamic invitation of perspective space. In an icon, the image is frequently frontal, its gaze meeting yours. The space from the picture plane to the gazer is the measure of icon-space. You are invited to participate in the gaze, but the invitation is outward from the picture plane and extending to the one who is looking. Perspective drawing invites you into the picture; icon art invites you to enter a new space that is literally created between the icon and the person gazing at it. For the faithful, that space is holy, alive, and meaningful. When one prays with an icon, one is present to the transforming quality that the presence invites.

When you enter into icon-space, or when icon-space pervades your being, you are in the transforming mode of becoming the thing you see. You are invited into sacred compassion. The Russian icon of the Vladimir Mother of God is a famous example of an icon leading the viewer into the depths of the Holy gazing on humanity. In the famous depiction by Andrei Rublev of the Trinity, angelic presences draw the gazer into a space of divine hospitality and communion. These spiritual and theological presences still impact with their intense life those who see them.

Icons are historic and prayerful expressions. They form a way in which a sacred image comes into being and a path by which the gazer interacts with it. We engage this holy seeing in a place I have come to call "icon-space."

Icon-space and art-journaling

Because of the essential importance of gazing as an aspect of art-journaling, I searched for a way to describe the approach that one might use with this discipline. I began directing the journaler to "Gaze on it and receive from it. Let it reveal to you, as you would an icon." Now, whenever I present art-journaling, I include an exercise of intentional gazing and have found that, over time, the experience of icon-space becomes a familiar and welcome place.

Traditional icons, objects from nature, significant photographs, and our own art-journalings: all of these things can become holy presences for our gazing and our contemplation.

Figure 5.1 Sacred images, traditional icons, objects from nature, familiar photos, and art-journalings all can become icons for our contemplative gazing

Your art-journaling reflections, done with humility and intent, and in the presence of the Holy, are vehicles of the sacred in much the same way as are the ritual icon images that bring the mysteries of divinity before our sight. With this understanding, practice gazing at your art-journaling, and allow the space between your gaze and your work to be holy. Listen to any parables revealed through your use of the elements of art. Bring this richness before the inner wisdom that desires to speak through nature and art, through mystery, silence, and darkness.

Noticing

"Notice" is an active, imperative word, a deeply contemplative way of living, a discerning stance, an ongoing awareness of life as it manifests itself, an incarnational spirituality. It is the key to the learning hidden in art-journaling. As we grow in holy noticing, the created world is illumined and reveals its outer and inner wisdom. If you practice contemplative noticing, you may be surprised by the gradual and progressive healing that begins in you. In your relationship with the environment, with others, with your history, with yourself, and with your images of the sacred, you will see with new eyes. You will be led to the revelation of truth, you will be slowed down. Gradually, the forgiving and transforming nature of things will shine forth from their place in Holy Creation.

Seeing creates

When we gaze at something lovingly, our seeing has the potential for creative growth.

We model the divine act of creative gazing as manifested in the creation stories of many spiritual traditions. One of these, the account in the Hebrew book of Genesis, describes how God sees, God names as good, and God calls into life.

This is the creative process at its most essential. Look back at your own art-journaling with those eyes. This divine glance is the way of seeing that art-journalers are invited to employ when they look not just at their own work, but also at their lives and at their fellow travelers. The gaze is non-judgmental in nature. It receives rather than analyzes. It belongs to the essence of contemplation.

Seeing with new eyes

You can experience the power of gazing through a relatively simple two-part exercise.

Go to a magazine, find a photograph of someone whose face appears to be looking at you, and cut it out. Spend some meditative time looking at your new acquaintance with a loving, creative glance; then, draw what that experience felt or looked like. Do some written journaling to focus your meditation.

Then, using the same photograph, shift your gaze into one of disdain and devaluing. Look at that same person and see if you can muster up the power of an uncreative glance. Spend some time with that experience. Draw what that feels like. Do some journaling, first about the drawing, and then about the differences in the look of each reflective drawing. Notice if you were able to shift to those two different stances, first of gazing with creativity, and then of gazing with a devaluing look. What were your own feelings, and how did the exercise affect you?

I had the opportunity of leading this meditation with a group of women studying to be spiritual directors. I handed out pictures of faces and sent them out for a period of twenty minutes to meet and gaze on their new acquaintance, practicing the loving gaze, and art-journaling the experience. When they came back to the room, instead of sharing the experience, they were directed to spend the same amount of time shifting that gaze, looking with disdain and devaluing at this same person. The shock and dismay in the room was so palpable that I almost rescinded my directions.

When they returned to the room a second time, some were visibly shaken. In the sharing that followed, their reactions were varied but very intense. One said that she was amazed at how easily she could switch to feeling anger at a stranger. Another felt that she was betraying someone she had come to know as good.

Jenny had received the picture of a well-dressed gentleman. She told the group how she had immediately liked everything about him. In her first gazing, she had felt trust. In the second gazing, he began to reveal his flaws. By the end of the exercise, she felt that he was belittling her.

The class ended with the suggestion that all of us were to notice how we gazed on the people in our everyday experiences and bring that reflection to the next session.

Class began the following week in a flurry of energy. People shared stories of encountering the usual people at their workplace, startled that they could look at them anew. One student, a social worker, explained how her clinical focus is on what the client is saying. Through years of working in challenging situations, she had become almost numb to the stories. This week she gazed, looking at her usual clients with a creative glance, and found that her usual cynicism was melting away. She was able to imagine possibilities for them and for their situations.

The reflection papers submitted at the end of the class confirmed that the exercise of gazing with creativity and with disdain was the pivotal learning of our time together. It has great potential to affect the most practical of experiences.

Seeing expands

We might not fully realize what a powerful activity seeing is, and how it affects others and ourselves. Think back. Have you had the experience of being looked on in a creative way by someone? Who are the people in your life who have gazed on you in a life-giving way? What was the outcome of that kind of gazing on your own life? Chances are, these are the people who called you forward, the people who inspired you, taught you that you could do anything, and that you had unlimited potential. Conversely, think of people in your life who gazed at you with disdain. They do not even have to be significant people; we all know the destructive feeling of that kind of gaze. It can happen in a chance encounter; it can happen in a crowd. Someone sizes you up with a look and you are pushed into a feeling place of insignificance. What was the result of that on your life? For me, such a memory brings with it a feeling of restriction, of shriveling. I am felt to be less and I pull back. I hide my true self, I protect my gifts, and I cover my abilities. Such a gaze has amazing power.

You may want to engage in art-journaling to probe your history of the creative and uncreative glance.

Recall some time in your life when you felt as if you were gazed on with a creative glance. Use pastels and design language to respond non-verbally to what that felt like. Gaze and do some written journaling to concretize your insights.

Recall the experience of being regarded with a look of disdain or belittling. Use art-journaling to respond to the feeling of that. Use art

materials and written journaling. Do some visual and verbal comparisons of these two expressions.

Spend some meditative time in nature and before beauty. Experience the gratitude you have for those times you received creative regard. Let go of the negative energy of the uncreative glance in your history. Let the experiences be healed in beauty.

After doing these exercises for yourself, spend some time paying attention to the ways you gaze on others. Notice the ways you look at those you love and the ways you may view a stranger. You will grow in knowing how powerful that communication is.

Art-journaling teaches us how important it is to gaze at our own lives with loving creativity. From the initial putting down of one mark on a piece of white paper, we are challenged to value that expression. In the same way that we gaze on Sydney's sun drawing, we must learn to gaze on our own. We have learned too well the gaze of judgment: "this is not good enough; this is not how I wanted it to look; this does not look as good as his; this is not artistic." Those voices may not go away, but you can learn not to give them power, not to let them stop you, not to believe their perspective.

Lessons in seeing

Throughout my life, teachers have appeared and changed my way of seeing. I have a vivid memory of one spring afternoon. I was sitting at a back entrance of a building on my college campus, looking out on a green expanse of grass. For my metaphysics class, I had managed to get hold of a copy of *Hymn of the Universe* by a Jesuit paleontologist, Pierre Teilhard de Chardin. The excerpt from his book referred to the "incarnation in matter" and his exposition made me aware of the flesh of the earth, and the aliveness in creation. I looked up from my reading and saw Matter shimmering before my gaze, transparent. That breakthrough into seeing has never left me. My eyes encountered the skin of the earth (Teilhard de Chardin 1961).

Years later I attended a creativity conference. For my workshop choice, I took "Meditating with Clay." The first set of instructions directed this group of strangers to close our eyes and hold out our hands. The waiting became a prayer. The facilitator made his way around the room quietly, placing a large lump of clay in each person's hands. Right

before the clay contacted my skin, I literally heard it. There was a crackling sound in the air above me, and then it came to rest. It was dense and heavy. With my eyes still closed, I saw the immense energy in the clay – this ancient and mysterious matter. Although I had attended numerous classes using clay and had studied pottery as part of my degree, it was as if I had never felt clay before. The darkness and silence was transforming and since that sacred encounter, I have always been able to see and listen to clay as mysterious and holy material.

In different corners of the earth, I have encountered artists who work in natural cuts of tree trunk and branch, finding the spirit of the wood in them.

There was a gentleman in Innsbruck, a crafter at Abingdon, a family group in Santa Fe, all wood carvers who touched the skin of the wood to find the ancestral forms in its hollows and folds. They sit and gaze long enough to see angels and ancients who return their gaze and emerge.

Figure 5.2 A receptive gazer saw an angelic form in the twists of a piece of cottonwood and created this figure

Practicing receptive/parable-seeing

In some workshops, we practice receptive and parable-seeing by contemplatively gazing at slides from museum collections. I direct participants to notice how the elements and images in those artworks affect them, negatively or positively.

I was showing a series of these fine art images. People were practicing gazing. They concentrated on identifying if and when a particular design element attracted them or repelled them. One of the paintings I had used was Dali's amazing *Soft Construction with Boiled Beans: Premonition of Civil War* (Moorhouse 1990). It is the image of man tearing himself from limb to limb and its realism makes it particularly difficult to look at.

In sharing, an older woman referred to that picture as one to which she was attracted. The group was surprised at that choice until she elaborated.

"I was drawn to that beautiful patch of blue sky behind the figure." On second glance, we saw that it was true. The background of the painting was bright blue and filled with clouds. We were stunned and spent a bit of quiet with her sharing. Perhaps the parable here was the woman's ability, hard won through years of prayer, to find beauty even in the harshest of places, even in the midst of senseless suffering, even in desolation and despair. She was invited to test that insight with her own inner landscape to see if the clue felt congruent with the gifts that she has at this point on the journey toward inner wisdom.

Deepening the attract/repel exercise

Using this exercise accomplishes several things. Gazing at examples of fine art gives you practice in learning to distinguish the elements of design in a complex arrangement. It also functions as a way to develop sensitivity to your inner stirrings by noticing places of strong visual energy.

When you identify a color or line that attracts or repels you, what is a good follow-up to that? You are repelled by the color red in the paintings. To soften, you might do a drawing using its opposite: cool greens and blues. This enables you to rest in the ability you have to move away from what is painful, and the power you have to create a place that is an antidote.

The other response might be to immerse yourself in what it is that feels repellent in order to conquer and understand it. So you do a drawing using an abundance of red and try to notice the things that you would usually notice in any art-journaling. You would pay attention to space and shape and to any feelings that would arise in the process of the journaling. You would gaze and then do written journaling to focus your reflection. In the end, you would see if you could figure out why you were repelled by the color red. Is it an association? Is it the intensity? Does going back to your former journalings and seeing where that color came in give you any clues?

Positive images

Sometimes it is beneficial to flood your life with positive images and move in that direction. Other times, it is better to concretize the distress you may be experiencing. In those seasons, painful images or visually aggressive elements might call out to you.

June was attracted to any picture that was loose and flowing. She could rest in colors that seemed to blend one into another. Karen had just the opposite response. She enjoyed the paintings that were more constructed, where there were shapes and edges within the drawing, clear boundaries, more rectangular shapes, definite beginnings and endings. Both of these women have a wonderful opportunity to see how their insights match up with whatever is going on in their lives right now. Does Karen need more structure in her life? Did these constructed designs yield relief? Or is structure Karen's natural way, and she saw her gifts echoed back to her in this visual representation?

June's enjoyment of the loose colors and shapes might mirror her need for this in her life. It could be the way that leads her to listen to something that she has not been able to hear through other avenues in her everyday life. Or again, the flow might echo the dynamic closest to her natural expression. Either way, it gives her a clue and permission to move into that dynamic to enjoy it and to gain needed energy from that particular way of interacting with herself and her surroundings.

Look at reproductions of fine art or visit an art gallery. Notice what elements call out to you, either positively or negatively. Notice your own inner spaciousness. Does it expand or contract when you encounter certain visual elements or themes? Write about that experience. This type

of receptive seeing can give us clues as to the direction in which healing awaits us at a given time in our lives.

During an afternoon museum visit, I encountered an intricate Russian painting. At first glance, the subject was an immense tree, rendered in imaginative colors and curving lines. As I looked, I discovered the images of people emerging from the organic shapes of trunk and branches. The painting kept revealing forms hidden in the tree. I was mesmerized, eager to identify the hidden faces and limbs. I found relief in this visual problem solving. The beauty of the image and the experience of deciphering its code were satisfying to my desire for understanding. That day I needed complexity to parallel the dynamic that was overtaking my life. At other times, a painting of simple crisp colors and forms may have refreshed me.

Take time to gaze at some of the art-journalings that you have completed. Notice similarities and differences between them. Shift into a place of openness. If you sense yourself being critical or judgmental, surrender that attitude and move back into spacious receptivity. Use the visual sensitivity that you are developing through the discipline of art-journaling to help you to receive from the elements of design.

As you notice your own feelings, and also the parables that may be coming to you through the design elements, move to any written journaling that will help you to clarify the *prayer, process, and product* of this experience. Continue to notice your own ability to remain a receiving *presence*, as opposed to being a judgmental critic of your own work.

Art-Journaling as Practice

"Practice" is a naming word as well as an action word, a noun and a verb. As a verb, practice is repeating an activity over and over for the sake of certain results. As a noun, practice is a discipline, a compilation of experiences that are cumulative in a learning environment. Art-journaling takes practice; art-journaling becomes a valuable practice on the holistic journey.

Individuals encounter different aspects of practice when they embrace art-journaling as a tool for meditation and a way to access inner wisdom. Jeremy found that it took some practice to really notice and identify art elements. Once this sensitivity developed, he utilized art-journaling very fruitfully and grew in his ability to read his own parable expression.

Rosemarie needed to practice non-judgmental gazing. An attitude of negativity had become habitual. It took her some time before she even noticed how often she belittled her own work. Once she became aware of that, she had to consciously work at substituting her critical self-gazing with a loving glance.

Dorothy enjoyed the tangible aspects of practice. She spent time picking out just the right sketchbook to hold her visual expression. She set up the arrangement of pages in a way that she could see her visual journaling on one side of the sketchbook and her written journaling on the other. She put aside a certain time every day to do the art-journaling meditation. She periodically went back to review past work. Doing that gave her an opportunity to notice the visual changes and themes that were emerging in her journaling.

You have reached another intersection in your journey. Now that you have done some real traveling into this realm, consider some of the ways in which you are building up your art-journaling practice.

Discipline

In any process, including ones of creativity and of prayer, nothing sub-
stantial is achieved without engaging the verb "practice." Doing some-
thing over and over gives you familiarity, erases awkward fears around
performance, and returns you to the discovery methods of a child. You
gain mastery, in the best sense of that word. You lose self-consciousness as
your response becomes more fluid. You stretch your ability to follow the
steps naturally. Discipline gives you the freedom to reveal without getting
in your own way. When you engage in any freeing practice, you acquiesce
to doing something with structure, regulation, and predictability in order
to house the unstructured, the serendipitous, and the spontaneous.
Practice gives you the flexibility to be creative.

Art-journal keeping

On a practical level, one result of doing art-journaling is the growing pile
of meaningful writings and drawings. You can decide to keep the fruits of
your practice in ways that are pleasant, organized, and even beautiful.
Arrange your art-journalings chronologically. Choose a spiral bound
drawing pad, date your entries, and include the drawn and written reflec-
tions in the same journal. In that way, you can notice progression, similar-
ities, and changes as different elements dominate or are subsumed. You
will see that visual themes tend to develop over time in the same way that
themes emerge from your written journaling.

If you prefer to keep your writing in a separate book, do that and
correlate dated entries with the number and title of your art expression.
Jane writes every day but only periodically does art-journaling. In order
to keep the journalings related and chronological, she developed a code
that helps her move back and forth between her two journals. She keeps
all of the writings in one book, but marks the entries that are accompa-
nied by visual expression with a red felt-tipped pen and records the title
in both her journal and the sketchbook.

Anita periodically binds her drawings in a homemade book. She
gathers pages that seem to summarize a theme. As she considers the series,
she will do an integrating drawing. This becomes a cover design for these
particular drawings. She uses a hole punch and yarn and creates a booklet

of a group of journalings that relate to a significant movement. Putting even a few entries together adds to the meaning for her.

Someone working exclusively with clay needs to be inventive with a system that keeps track of the work in relationship to the writing. Jennifer sets aside a shelf for the sculptures she does during a given month. This provides an opportunity for ongoing noticing. The dialogue between forms influences her writing during the four weeks that one clay group develops and is in her sight. She has taken to naming each clay expression based on some physical attribute and uses that designation in her written journaling as the month's practice develops.

Figure 6.1 This art-journaler regularly worked in clay and examined her sculptures monthly to notice visual parables such as emptiness, fullness, space, presence, and light-heartedness

Being creative

Do you have to be creative to have art-journaling as a practice? To engage in art-journaling, is it better to be an artist? Do you need to have mastery over the art materials that you are using?

I meet individuals who choose to attend an art-journaling workshop, then shy away from using the art materials. They claim to lack creativity. When they are invited to work with oil pastels and written journaling, they resist, reacting with anger. The resistance may come out in outbursts such as, "This is stupid, childish, a waste of time, fluff," or in sabotage. They hold up examples of their negative encounters with creative activities. They criticize the art materials, or the schedule, or the meeting room. Underneath this resistance is the voice of a hurt self that sustained an injury to its creative core. Eventually, they reveal the source of this response, usually a childhood experience of perceived failure. If they were once told that they were not creative, the resentment of that judgment comes to the surface. When faced with the invitation to reenter the realm of creativity, their spirit flinches. Touching that injury yields pain and its accompanying protective anger. When they allow the anger to surface but not overcome them, they find it possible to engage with the art and writing in a fruitful way. Then the practice becomes a healing activity, an exercise whose careful development can replace the wound with new skin, and the injury with flexible movement.

Artists and writers

Ironically, there are times when being an artist can get in the way of doing art-journaling. I tell people that someone trained in art has learned ways to manipulate the visual expression. If a person puts conscious energy in making the visual response look good, by avoiding a messy expression, she may miss a deeper message. The trained artist might discover that the most incisive place of revelation comes in the verbal reflection. Venturing into the realm of written clarification of the imagery puts a completely different energy into the visual artist's mix.

The person who has not had art materials in his hand since he was seven years old might find the use of art materials most effective. The skilled writer will find great energy concentrated in his visual imagery.

The drawing will energize his writing and add to insight in a way that words alone cannot touch.

A word about art materials

I continue to recommend oil pastels or earthenware clay as art-journaling materials. However, art-journaling exercises can be adapted to any art medium. Sometimes a good way of expanding a theme is to redo that theme in a different art material and see what the second version adds to the original expression.

It is important to consider how the qualities of your art materials enhance and support your structural journaling. A simple lead pencil can provide you with a wide range of line, tone, and texture. If you wanted to emphasize line, you might choose a felt tip pen. They come in a variety of thicknesses, with either permanent or water-soluble ink. Permanent ink will not smudge or run when moistened. With water-soluble ink, you can use a brush dipped in water to soften the lines. Using black ink with a drawing pen or brush can provide expressions of great contrast and spontaneous movement.

You might utilize colored pencils and pens, markers, or soft pastels to add color.

If you want to work with paint, you could investigate watercolors, tempera, acrylics, or oil paints.

If you want to work three-dimensionally, there are all types of clay: earthenware, porcelain, self-hardening, polymer, even playdough. Carving into a material brings with it another set of parables. Anything from a bar of soap to a slab of marble can receive the activity of being carved into or chipped away.

Many other art materials can be excellent vehicles for parable expression in art-journaling. Scratchboard is a traditional medium of paper coated with a thin layer of clay. The clay layer is inked, and a scratching tool is then used to cut into the black surface, revealing the underlying white line.

You can journal in the process of creating a collage. Use words, colors, textures, and symbols cut from magazines, arranged, and pasted on to another surface. On a larger scale, any variety of items put together in a

journaling fashion to make a statement can be material for a collage. Working this way can be freeing and unifying.

Each of these materials has limitations and possibilities that can lead to modes of expression. As you embark on the adventure of using a variety of art materials, allow the qualities of the materials to be a parable.

Using art materials

It is not a good idea to learn the complexities of an unfamiliar medium at the same time that you are trying to use it for expression. You can become caught up in the temptation of what is the "right way" to use this paint, this brush, this pen point. Get acquainted with what a medium can do, and explore its properties freely. When you have reached a level of comfort with its liabilities and its positive qualities, then use it for art-journaling. If you do become distracted by the intricacies of a material, either change back to a familiar medium or use the opportunity to confront the "doing it right" troll through some journaling!

Theoretically, any art material can complement your practice, but working with an unfamiliar medium is another agenda and can confuse the issue. Margaret wanted to do art-journaling with watercolors. She loved the appearance of watercolor painting but had never used them herself. My suggestion was to learn the medium first in a setting that would teach the limits and assets of watercolor. Take a class whose goal is the mastery of the aspects particular to this type of paint. Different art materials can be surprisingly complex. Frustration with the materials can confuse your expression of a journaling subject. How will you know the difference? How will Margaret know if it is her inexperience with the watercolor that is making the journaling muddy, or is it an aspect of her life that is muddy? Suppose she is having trouble creating a smooth surface. Does that have to do with how she is using the paint, or is it indicating that a relationship in her life is not smooth? If you have some facility with the medium, you are more easily able to make that distinction on a soul level rather than on a technical level.

Susan told me she was struggling to blend the oil pastels and decided to use a chalkier pastel to get the results that she needed. She switched to the soft pastels but with the recognition that whatever medium she chose, the dynamic she was seeking was a softening. The movement she was

being invited to explore had something to do with blending the edges of her experience.

Trusting color vocabulary

Before I begin presenting an art-journaling session, I always say a few words about color. You have already met color as a design element, but this information comes from working with unique individuals. There are many wonderful books about color. I have seen some that include the names of colors and their meanings (Fincher 1991; Corvo and Verner-Bonds 1998). I am, indeed, fascinated with psychological and archetypal color theory, but I strongly resist limiting the interpretation of a particular color to lists connected by equal signs. We are not to be delivered from mystery quite that easily!

Each of you has your own color vocabulary. You might not be aware of it, but as you begin to make choices, it will become more obvious.

A woman I work with in spiritual direction keeps an ongoing notebook of her visual journalings and brings them to the direction sessions. At one point in our gazing, I noticed a new design element appearing in her expression. It was manifested in a strong use of the color black, something that I had not seen in her previous work. I asked her to reflect on this newness in light of any sense she may have of inspired movement in her life. After some time of quiet, Lisa recalled that as a young child who studied dance, she had a memory of wearing bright pastel colors. As she matured and reached mastery in her movement, she was allowed to wear black. Black was a formal color for her, signifying accomplishment and achievement. In her present life, she was approaching a vocational decision that held the possibility of significant commitment. As she spoke, we both recognized a peace and confidence coming from a deeper place. For her, then, the appearance of the color black in her art-journaling signaled something positive. It became an eloquent comment on an interior movement. If we had analyzed this color together, rather than allowed it to manifest as grace through the history of a unique individual, we may have missed the edge of grace waiting for both of us. We shared a place of receptive seeing, allowing the element of color to become a parable (Hieb 1996b, p.7).

Practice and visual sensitivity

Because it has become a significant psychic symbol for me, I have developed a visual sensitivity to milkweed pods. This is a tall weed that houses millions of winged seeds. I can be driving down a highway, and I will distinguish its tall stalk growing on the side of the road. Even in the midst of many other weeds, my eye knows the shape of its leaves, and the unique appeal a milkweed has. I recognize it, even before it has grown tall, even before it has formed pods. When it is open and empty, it still speaks. My eyes and soul are practiced in discerning that graced presence in the world around me.

One of the pods has cracked open ever so slightly — revealing the promise of seeds...

Sunday September 3 9:30am

Figure 6.2 A pen and ink drawing of a milkweed pod as a significant symbol of life-processes

As you work with art-journaling, elements from the created world will speak more eloquently to your sight. In times of pain, you may be drawn to the twisted vines or rough textures of trees. At other times, the delicate unfurling of ferns will attract you. Rocks and withered plants, the

patterns of cracks in a wall or on a sidewalk, the brave weed pushing through a breach in concrete will draw your vision.

At the same time, it is important not just to let these visions come to you, but to put yourself in their path. Go out and intentionally spend time slowing down your pace. Let your eyes rest on your surroundings. Distinctions will sharpen and the practice of gazing in a contemplative way will call you to insights in a way that keeps developing.

Figure 6.3 The milkweed silhouette is recognizable from a distance to the attuned seer

As you walk along, notice what part of the distance stretches out before you. Notice the place where your sight resides (Dillard 1974). Do you see into the deep distance? Does your gaze capture the articles right in front of you? Have you ever taken the time to notice if you have a place of habitual gazing? Your visual sensitivity can be honed, tuning you into the close up, distant, and middle ground areas of your everyday life, where mystery and simple delight await your open glance.

Finding a voice

As you move forward in life, it becomes increasingly important to find your authentic voice. The invitation to become congruent with your inner and outer life is intensified.

There is a spark within that seeks manifestation; there is an urgency to express. Art-journaling can be a way to manifest this spark and to discover the original voice. Practice will deepen the experience of inner trust. The process itself, utilizing the combined energy of your strengths and of your shadow, will push you to the edges of expression. The contours that elude you when you use a single journaling approach appear in stark relief with the combination of non-verbal and verbal exploration.

Doing it right

When competent adults embark on something unfamiliar, they are tempted to worry, "Am I doing this right?" Especially when challenged by something that is termed creative and might then reveal a lack of talent, the "need-to-do-it-in-the-right-way" troll rises from under the bridge to taunt you. That presence can keep you from engaging freely in a process whose very nature shouts out: there is no wrong way to do this! There is your own unique journaling response.

Have you ever worked with a dream to understand its meaning? Sometimes a dream will reveal its significance immediately. Sometimes you are left with a feeling or texture that slowly makes a connection to your waking life. Sometimes you just walk around that day, shaking your head and saying, "What was that all about?" Art-journaling shares in a parallel process of revelation.

The "doing it right" troll gives rise to the complementary dynamic that plagues the ordinary person, a tendency to be judgmental in the midst of your attempts to be spontaneous and free. Notice when that voice comes in – "This is stupid; I can never do these artsy things; this is a waste of time; everyone else is doing it right; I have no talent…"

In a workshop situation, I urge the participants to listen actively for this voice, and to notice at what point it comes in to sabotage their work. You can be sure that, if this happens in a workshop situation, it happens with much more power in the everyday. If you can begin to identify it in

structured exercises, you will start to recognize its undermining face in routine interactions of living.

Doing and being

There are differences in processing, varying ways that individuals approach, conceptualize, and respond to the art-journaling experience. It is your uniqueness that will guide you in moving through the process. Some people start with an image or a concept, and then try to draw it; others begin with the color, and the image or thought emerges. Sometimes the same person will shift among differing processes. There is no single way. People come, in distress, telling me that they want to work more spontaneously. They work hard at suppressing an image, afraid that this spontaneous concept will get in the way of expression. They judge something conceptualized as less free! In the meantime, they ignore the wonder of having received this rich image. Better that they get out of the way, stop judging their way of processing, gaze on the image, and get to know it.

My advice is to honor your way, and it will serve you in greater and greater freedom and giftedness. Some individuals image or think, and then draw; others seem to draw first and then formulate, recognize, and name. Can you notice the way your non-verbal journaling happened?

Doing it!

Do this practice of art-journaling for yourself! People who come to my workshops often share their hopes for the experience. Some will say that they want to learn about this in order to take it back to the parish group, to their therapy clients, to their directees, and so forth. They want to take a lot of notes. This distances them from the experience. I urge them to do the exercises for themselves, to enter into the experience, and to put themselves at the disposal of their own creativity. In going through the process, they will be enriched. The techniques will become their own, filtered through their own giftedness and their own perspective. The only authentic leading comes from a person's experience and not through techniques appropriated in an external way.

We have all had the experience of someone thanking us for doing or saying something that was meaningful or comforting. We smile and

inside are saying, "When did I ever say that?" Often people hear what they need to hear, and we are privileged to be the instrument.

So, do these exercises for your own seeking. Allow them to be openings into the abiding wisdom within you, and within the universe. In approaching that mystery, a deeper well is formed, a place of refuge for others.

Timetable

Doing art-journaling takes time; however, it does not have to take very much time. In some circumstances, it happens in a flash. In an instant, a mark on the paper, the choice of a color or a single word, can reveal what you needed to hear in order to move forward on the journey. In other situations, the drawing of the image, the companion journaling, and the gazing can continue over a long period of time.

One woman I worked with did one art-journaling each month. In meditation she would wait for a word or phrase to become her theme, do the art for as long as it took, do written journaling, and then place the work in her prayer corner. It remained there for the month and, invariably, the word, the image, or the journaling would deepen over time, revealing more. She practiced receptive seeing, allowing the process to speak.

I know other clients who do a short journaling almost every day. They find it helpful to develop a series of sequential works, and look at them periodically to notice changes and similarities in the visual and written development.

Your timetable with art-journaling practice will vary with the realities of the season. Internal and external circumstances monitor the ebb and flow of the appropriate practice for a given time.

It is important for each of us to attend to the seasons of our whole selves, and not impose specific expectations or practices that are not possible in our times of dryness, desolation, or need.

This is an account of one woman's art-journaling practice at a time during which she felt unable to formulate a relevant theme. She uses this prayer question frequently, and has discovered that it fits her current circumstances in a way that other prayer practices cannot right now.

I just sit down in a quiet place and have my art materials around me. I turn toward Mystery and I just say, "What?"

Figure 6.4 An art-journaler's response to the question "What?"

And then I try to listen.

The "What?" is an expression, I suppose, of my desire to be willing to listen to what life or the Holy wants to reveal.

Last year, I went through a difficult time. Since then, for the most part, I have felt as if I am in darkness. Not trusting my usual good intuition, the prayer of "What?" helps me in its simplicity. I don't even know what I want to ask or what my "theme" is. Often if I am still, something comes. Usually I don't know what it is. Sometimes I know later. Sometimes I am content just to have taken some quiet time, and I remain in the unknowing.

This is the written journaling that accompanied a recent prayer of "What?":

I start out feeling "feelingless" and am surprised by the intensity of the color that I use.

As I work, my breathing deepens. I sense the tightness in my body and feel it let go a bit.

First, I draw in outline a flame shape. I use blue. It is a cold color.

Inside, bright green – hope – then quickly I need to add black to that, because the hope is tainted.

Then I surround the core with grey (depression)? Then red (anger? pain?) Then brown – earth, ordinary, everyday (death, burial?).

I look at this for a while, then draw a purple spiral at the bottom of the form.

Is this a loosening?

Then finally, I use a young green color, just lightly, first, just a touch, then covering more area – because I can't deny that there is hope, growth, life beginning even in the midst of what feels like solid pain, depression, anger…

I gaze at this expression, somehow not sure that I can accept the light green hope…

Wondering if I am forcing something positive?

So I wait longer.

I realize that I can trust the light spiraling movement.

And the green is gentle and faint – a light call not competing with the heavy colors, just being present, not trying to take it away…

God wants to know, perhaps, if I can just let it be there, let it coexist. Accept the glimmer of light green. I try to say yes. God accepts my difficulty. I let everything be.

Later, I come back and look at the art-journaling again:

I am startled to realize that I am the one who "stopped" the green. I did not let it get bigger. Did it want to? Could it have? What would it

be like to keep going with it, allow it to take over the picture? Am I resisting, withholding? Can I ask God about this? Am I already doing that?

As an aspect of your practice, in times of darkness or unknowing, you may want to utilize the theme of "What?" as an organizing factor for your art-journaling.

In other seasons of growth or change, when definite questions solidify, you can embark on themed exercises that will bring those matters into clearer focus.

An icon prayer place

When possible, designate a specific area for your practice of art journaling. The same space may also be a place of prayer in which sacred objects rest as icon-reminders of the presence of the Holy. As you work, you may discover certain art-journalings that challenge you to abide with them for a time. You might put these pieces in a special frame and hang them in your prayer space. You might bring back a piece of nature from a retreat or other journey, and set it in your icon place. What are the things that will bring your heart and mind back to that place of turning toward the Holy? Utilize them in a special and visible way to intensify your sacred experience of prayer with art-journaling.

Practice and Core Themes

As you gain experience in moving through the art-journaling stages of posing a question, responding with art materials, gazing, writing and noticing, there may come a time when your insights coalesce around a specific dynamic. Practice gives you the ability to identify when a focused movement is emerging in your life. The manifestation of core themes such as discernment, resistance, grief, loss, or illumination signal essential seasons in your life that warrant your attention.

You have already read stories of art-journalers recognizing their own core theme. Peggy's awareness began by a simple revisiting of her history of being overweight. In gazing at her art-journaling, she found that elements of her life were gathered at a decision point. It was time to engage in a significant change. She identified other health concerns. She paid attention to her withholding until she could make a discerned response.

Resistance sets the stage for important breakthroughs. Trudy was resistant to looking at the relationship she had with her children. Her willingness to journal about that specific area was a beginning. She discovered that the resistance was pervasive. The weariness it engendered required her attention at a deep level.

While engaging in clay work, Tony found himself surprised by grief. The realization of bereavement descended and his entire history of past losses opened up to be revisited.

As you develop practice, there will be seasons in which you will identify core themes at work in your life. You recognize that you are traveling in the sphere of *discernment*. You admit that you are up against a place of *resistance*. You succumb to a season of grief; you are overwhelmed by a sense of *loss*. You find yourself in a place of simple *illumination*. Everything in your life seems to be in relation to one of these core themes. For

those times, it might be helpful to work in a focused way. There are some gentle suggestions, as well as some guided exercises, that might fit. You can use them whenever you suspect that an abiding single way is leading you.

Discernment

You have a sense that change is happening around you, and you want to address it more intentionally. If you are feeling restless in a situation over a significant period of time, you may be on the threshold of an invitation. At evident or subtle choice points in your life, you may want to explore discernment as a core theme.

A season of discernment brings you to serious and evident crossroads. Discernment is a process, and its timing must be honored. You spend time identifying and intellectually considering your alternatives. Something has to be discarded and something taken up. When you are struggling to make an informed decision, and have gathered as much information as you can, the next step is often a leap of faith. You may hover on the edge, not eager to recognize whatever is pushing you forward, and not welcoming the unknown. At that edge, using an art-journaling meditation can be so helpful, for it allows your spirit to express what your heart already knows. The expanded information from an exercise with color or clay could shed light on some tiny glimpse of wisdom you may be overlooking.

Clarifying alternatives

At a time in her life when she was facing the question of changing jobs, Sarah added the discipline of art-journaling to her discernment process. She found that the use of art materials slowed her down and allowed her to talk to herself about the tiny flame of clarity within her. Written journaling and sharing the spoken word cleared the way for freedom to emerge in the midst of her busyness.

I was considering whether it was time to change ministries. I had prayed, reflected, and discussed my options with several other people over the course of about eight months. I sensed some invitation and even challenge, but felt blind to its contours. One day I wrote out a list of discernment questions:

- What would it look like, feel like to stay in ministry at the homeless shelter?

- What would it look like, feel like not to stay at the homeless shelter?

- What would it look like, feel like to move to hospital work in pastoral care?

- What would it look like, feel like not to move to hospital work in pastoral care?

Pushed by the practicality of a deadline, I took a box of oil pastels and a large pad of paper, drove to a nearby park, sat in the car and used the pastels to respond to each question. The result was startling and eloquent. By gazing at the ways I had used color, line, space, shape and energy in each response, I could easily "read" some deeper truths of the edges of grace and my own intuitions. I wrote down a few swift reflections, but I had already come to clarity in the power of the visual responses. The very next day, I made an appointment with a person to share this journaling and to enter into a confirmation process around moving to a new ministry.

Sarah enhanced her decision-making process by using art-journaling, and being attentive to the journaling's revelation. The spontaneous and non-representational drawing, accompanied by reflective gazing, written journaling, and verbal sharing with another brought the discernment prayer to its fullest clarity.

Discernment and art-journaling

A vital step in the discernment process is information-gathering. Much of that work is done in a deliberate and linear way. At some appropriate time in the discernment, working with art-journaling can yield another level of wisdom. The insights filtered through the art-journaling process can then be brought to the data already collected, to give you a more complete range of intuitive, historic, and deductive knowledge.

Discernment exercise

Come to this prayer exercise with a specific decision under consideration. Gather your art supplies. Plan on using as many pieces of paper as it takes to draw out each of your alternatives.

Allow yourself some time to settle. Begin by seeking the grace of freedom, opening to the transforming light of wisdom.

Creating discernment questions can be liberating, as well as practical. Name with clarity the various alternatives that you are facing. Each question yields information, and should be accomplished as part of a process. You gain knowledge and insight on the other levels of your awareness when you join thinking and judging with a spontaneous use of color, energy, and elements of design.

It is important to formulate statements, and to create them in a way that the positives and negatives are clear and relatively simple. Sarah created four questions when she was deciding about a change in ministry. Your decision might be broken down into many more alternatives. Create as many questions as you can, even if some of them seem a bit outrageous. Express the pros and cons of each choice. The wider your scope, the more clarity is possible as you recognize the spark of truth in the midst of the series.

Do each drawing as if it were the only one you were doing. Give each theme your full attention, dropping down to a place of expression that speaks the truth of your inner vision through line, color, and energy.

As you move through these questions, notice if, at any time, you are reluctant to continue the exercise. Pay attention to your holistic presence. For example, you are ready to begin the third drawing and you experience a feeling of exhaustion, of minimizing, or of belittling the process. If there is a sudden release of energy, frustration, fear, or relief, at what point in the process is that happening? Look carefully at the drawn elements and allow them to speak to you as a parable. Finally, put into words anything that you notice as you gaze upon your drawings. For added clarity in a discernment process, you may want to share the fruits of this meditation with a trusted other.

Personally, I engage in this exercise very respectfully. Once I begin it, I can be faced with a level of information that will be hard to refute. Twice in my life, art-journaling has dramatically altered my perspective at a crucial decision-point. Both times, within one of the drawing series, there

was the manifestation of very small, but deeply significant, elements that became the clearest grace of revelation. Using this process prayerfully brought clarity that was more holistic, urging me forward, even as I was trying hard not to "rock the boat." Despite my reluctance to admit it, my heart's decision was hidden under a heavy sense of "This is what the good person would choose." Art-journaling allowed me to rest in my own truth until I was ready to see and claim it.

Discernment and serenity

The *Serenity Prayer* can serve as a basis for another perspective on discernment. In the Human Wholeness Retreats, we use The Juggling Act Inventory (Tubesing and Tubesing 1983, pp.26–27) to take a look at the creative stressors in our lives. The participants write down their stressor in circles that surround a line drawing of a juggler. Once the stressors are named, they are viewed through the template of the *Serenity Prayer*: "God grant me the serenity to accept the things I cannot change, the courage to change the things I can, and the wisdom to know the difference."

The participant is invited to scan the stressors and notice which ones are within his or her power to change. Once identified, the retreatant can decide if she/he is ready to do something about each, one at a time. The retreatant then considers those things over which she/he has no control. Does the client want to ask for the serenity to accept these? Perhaps she/he needs more time to ripen into this response. In this exercise, wisdom is put to the test, as each asks for the gift of making authentic distinctions.

This process helps in discernment and can be utilized with art journaling. You can draw what it might look like to accept a particular thing. You can image how it feels to be challenged to change something. You can journal what it would look like if wisdom intervened.

There are times in your life when you are struggling to make a decision in the face of complexity that is beyond your control. Writing out the phrases of the *Serenity Prayer* and dealing with the situations in your life in the light of each phase can give a needed perspective. Begin with the situations that you can change. Decide if you want to, and if there is a readiness. What would it take to make those changes? Create a reasonable and progressive plan. Ask for courage. Use art-journaling with each situation that you are considering.

What are the aspects of your life that you cannot change? Identify the situations over which you have no control. Hold them in the light of serenity and ask for acceptance. Be open to receive the wisdom to make these distinctions through drawing and journaling.

Resistance

Interestingly, resistance is linked with discernment and is sometimes the place where the real decision is hiding. At times, you recognize a need to be present to the edges of resistance where revelation waits for your discovery. Resistances are deeply eloquent comments on your relationship to situations and people. Moving through your resistances, your jealousies, your fears, and withholdings is a creative act. Creating more truth and beauty in the world moves all of us forward.

The ability to distinguish the presence of resistance is often the initial grace. You need to wait at the threshold of your own chosen blindness for the resistance to appear. You recognize its contours by the surprisingly strong presence that its shadow throws onto your everyday encounters.

When I had a leg injury characterized with stiffness, I experienced physical resistance. If I pushed beyond a certain point, I experienced pain and the possibility of more injury. Should I rest my leg and not engage in movement? Should I push into the injury to the point of tension and hold it there, gradually stretching the muscle to regain flexibility? Either way I was working with the resistance of a muscle, trying to listen to the wisdom it needed. The presence of resistance in my muscle gave me a range of experiments as I tested out the alternatives, seeing which one was more effective. Some days one would work better than another. It took a longer time than I had imagined, but the resistance yielded back into health. So it might be with this resistance that has manifested in your life of grace. Listen to it and learn from its presence in your life.

Resistance and art-journaling

When you suspect that you are meeting up with a resistance, here is a series of art-journaling questions to help you glimpse its silhouette.

Resistance exercise

You will need four or five pieces of paper to complete the entire series of questions, as well as oil pastels and your writing implements.

Bring your desire for openness and receptivity before the spirit of Wisdom. Ask for the grace to recognize any resistance that calls to be held out to the Holy.

Resistance may be a condition with specificity (e.g. resisting an exercise regime), or it might be a pervasive feeling without firm contours. Either way, you can use art-journaling to probe its mystery.

The exercises for this theme have several possible parts. The first one helps us to image the resistance; the following ones aid us in imagining how this resistance might alter if we were to let go of it, battle it, or allow it to soften.

As you are ready, work with pastels and paper, attempting to respond to some of the following prayer-questions.

Posing the question

What does this resistance look like/feel like?

As you consider the question in an art-journaling way, attempt to represent how big, small, dark, wide, dense, or full this resistance is.

There are three different questions that follow. These pose alternatives to dealing with the resistance. Praying with them might yield the graced direction to take in relation to the resistance.

- What would it look like if I were to let go of this resistance?

- What would it look like if I were to push against this resistance, to engage it, to battle it, to overcome it?

- What would it look like if this resistance began to yield, to soften?

Consider each approach and draw it as if it were the only perspective. Then, in a reflective way and with openness, look at these four journalings together, and spend some time both in receptive gazing and in written journaling. It is important to receive from the images, and let them speak on a level of parable.

With these questions, it is particularly significant to notice your holistic presence during the exercises. When we are dealing with resistances,

there are gathered feelings, tightly bunched muscles, and dense areas on every level in our lives. These places may yield information unwelcome, but necessary. Physically, we may experience resistance as tight muscles; mentally, as tied up thoughts and feelings; spiritually, as places of withholding. Can we begin to notice this language as it is expressed visually, through elements of design? Praying with this in an art-journaling way can cause movement, and can hone in on those bunched, dense places in our bodies, our minds, and our spirits.

This exercise can be repeated as the resistance gains clarity, or as it gradually softens. Sometimes a knotted muscle will let go all at once. More often, the letting go is a gradual process, a kneading that softens the muscle back into a more relaxed and natural state. In our own lives of graced challenge, we encounter the feelings of resistance and of yielding, of tight muscles, of annoyed minds, and of withholding spirits.

Looking at the art-journalings together can help you to stay with the prayer process. Does the comparison among these pictures, and your reflection on the process of doing them, give you any clues as to how you might proceed? Perhaps doing a summary art-journaling on the wisdom revealed in this resistance will concretize your commitment to a specific way of dealing with the resistance gracefully.

Sharon shared her experience of imaging the resistance.

In response to the question "What does this resistance look like/feel like?" I drew a black box. It was a hinged chest with a secured padlock. In the empty space above and around it I drew dark question marks.

In the prayer of gazing, a remarkable thing happened. I imagined pushing against this resistance and the locked box image only tightened… I then considered "What would it look like to let go of this resistance?" and I drew a blank. But when I prayed about allowing the resistance to soften, the image transformed. I realized that the box was a treasure chest and the questions became keys that would unlock the chest. I embraced the reality of the questions and was open to considering each question, believing now that one or all of them held the secret to unlocking this treasure. The follow-up journaling expressed my willingness to deal with the questions not

as the burdens I have been carrying but as ways to unlock the mystery I am seeking.

The direction was clearer. I would try to identify the questions then take some time to let their wisdom relate to my treasure box. I had a feeling of hope that the box would be opened.

Frank knew he was refusing to forgive someone. He was impatient, thinking that he should be magnanimous enough to grant pardon. Meeting up with a stubborn reluctance felt uncharacteristic. He decided to draw what this resistance to forgiveness looked like.

He had difficulty in the initial art-journaling, and expressed very little energy in imaging the resistance. When he took up the question, "What would it look like to let go of the resistance?" the strong edges of anger began to surface.

He had focused on his inability to forgive in the midst of a painful assumption that the "good person" should forgive. Instead of getting to know his own unforgiving attitude, he discovered rage. Resistance had been masking his reluctance to admit that he had suffered an injustice. As he progressed through a series of drawings, he discovered great personal pain underneath that anger. The revelation of pain put the resistance into perspective. It was with this pain that he went before God in prayer. He put aside a need to chastise himself about an inability to forgive. Instead, he was present to an interior injury and open to the process of healing. The real nature of his resistance surfaced along with Frank's openness to receive a compassionate gaze.

A retreat group had just completed the life-elements drawing. When I asked if there was a theme or question that came up for anyone, Gloria's spontaneous response was "resistance." She invited us to gaze at her journaling, pointing out a fuzzy gray line holding down other colored shapes. Although it wielded power in the drawing, the gray line was not very solid or strong. In considering how she felt about resistance in her life, Gloria was surprised to realize how weak the line actually was. In a follow-up visualization, she imagined that the fuzzy gray line blew apart into little pieces. In her next art-journaling, she depicted a positive presence moving through her original drawing, collecting the pieces of the fuzzy gray line into a basket. The journaling took on a whimsical feeling. She did not know what the outcome of this gathering activity

would be. She wondered if the line needed to be put back together again or not. She felt in an unknown place, but was keenly aware that she felt no fear. She was willing for the process to continue to unfold.

Loss

Loss may be one of the faces of surrender that you encounter in the process of understanding your response to resistance. Loss may be a covering for grief, a season of abiding that has its own timing. Notice the ways that loss may be present or manifesting. Let darkness and emptiness have a voice, and use the tools of art-journaling to probe the authentic voice and silence of a given time.

The process of art-journaling can allow you to sit at the portal of grief. Sorrow and loss have their own timing and you are invited to ride the waves of an ebb and flow that responds to a movement outside of your planning. In seasons of grief, the alone time that art-journaling can provide is sustaining. Quiet images or turbulent colors and lines accompany you. You allow yourself the healing space to let the lines or hollows emerge, and then you gaze at them. Any sharing that might follow, even with yourself, can be left to your own timing. Often it is enough to put down the image. Later you can return to it in a way that asks for words or clarity.

I was leading a group in the weekend experience. As I began my presentation, the woman right in front of me grabbed a piece of black paper and began a vigorous drawing. I gave a series of explanations while she used the colors, oblivious to her surroundings. Eventually, I posed a question and sent the group to work on a theme. Later in the day, this participant came to discuss the black drawing.

"I needed to get out the images before I could do anything that you were going to ask." She described what emerged as a page of tears in all different colors. As she formed each tear shape, she tried to push them against each other in aggression, but the colors kept flowing together. The beauty she ended up with on the page amazed her. Later, when she shared her process, it captured the imagination of Christine, another woman in the group. Christine had come up against some strong feelings in her own drawings and was reluctant to follow the intensity. She sensed a deep grief underneath and was afraid that "if I began crying, I might

never stop." Helene's tears picture became a safe symbol for Christine. It helped her to be more courageous in viewing her intense feeling as giftedness. Christine created a series of meticulous drawings using a circle as a structure. Each circle contained an individual memory. Through Helene's sharing of the tears drawing, Christine was empowered to move into her own grief in a specific way.

Sylvia, a young mother, had experienced the loss of several family members in a short period of time. In her initial drawing, she represented her grief in a box. She shared with the group her process and beginning insights.

> I knew I compartmentalized my grief and set out to do the drawing that would make it visible. I drew on the path outside and the pastels picked up the rough texture of the pavement. It was exactly what I needed as a background to my journaling. As a mother, I have felt that I needed to go on for my children and not indulge in the feelings of loss that sometimes seem very close to the surface. As I created the grief box, other boxes also appeared in the drawing. I saw that it was not just the grief that was boxed in but other parts of my life as well. In being unable to be with the sadness, I was also separating myself from my real personality.

In the next few drawings, Sylvia began to gaze on her whole life, beginning a process that would differentiate roles. Now she could choose to reclaim not just a grief process, but also her identity as a whole person. She made a bridge into her ordinary life by creating a journaling practice that took into consideration her fuller self.

On a retreat, something as simple as holding a chunk of clay propelled Crystal into the grieving process that had eluded her as a child. We were sitting in a circle using a large piece of clay as a focus for our prayer. Each participant made a mark on the clay and then passed it on to the next person. At the end of the experience, Crystal shared how the feeling of the clay reminded her of the coldness of death. She was startled by a vivid memory of her mother in her coffin. Touching clay brought her into the presence of that death experience in a way that nothing else ever had. This encounter with the edges of art-journaling brought a painful memory into the beginning of a healing process.

Another encounter dealt with loss in a different way. Miriam had recently undergone surgery for cancer. People in her life had been amazed at her rapid recovery. She was able to resume her duties in a remarkably short time.

Miriam's first journaling expressed her lack of feeling in relationship to a ministry that used to give her joy. The accompanying written journaling led her into the realization of other losses in her life: loss of friends, of interest, of a feeling of accomplishment. The essence of this loss eluded her.

Later in the retreat, she was prayerfully using clay with her eyes closed, listening to its wisdom. When she opened her eyes and gazed on the clay, she was startled by a felt realization that she had lost parts of her own body in the operation. She recognized that she had never mourned this loss. Her focus, and that of her companions, had been on a return to health. The prayer with clay opened up a new perspective on loss. Miriam decided to take the clay pieces home with her and bury them in a place of significance, to recognize and honor her experience.

Loss, art-journaling, and holding

The exercises and stories dedicated to the theme of grief and loss are varied. If there is one constant, it is probably on a person's need to be present. Art-journaling can help you abide at a time when words elude, or when it is painful to spend any length of time with feelings. Rather than presenting structured exercises, a movement toward loss, grief, and even physical pain can be the invitation just to hold the grief and allow Wisdom to hold it with you. Sometimes your presence to loss in small doses allows the spirit to rest with the immensity of the grief. On the other hand, in your work with art-journaling, the reality of loss may appear unbidden. As with Miriam, while forming a piece of clay or gazing at a line quality, you may catch a glimpse of the scale of what you are dealing with in the everyday. Your inner wisdom is the guide, leading you to abide with gentleness in a season of loss.

Loss and abuse

Abuse is related to loss in some ways. Using art-journaling to express aspects of abuse can allow a person to gaze on the unspeakable. It is a process for the courageous, and only after some healing has happened in

a way that is therapeutic. Helpful professionals and programs support the healing of people who have suffered physical, emotional, and spiritual abuse at the hands of a trusted other.

At the point at which someone is invited to visit the pain in a way that is visual, art-journaling can be a supportive process. I recommend it as part of a larger context of counseling, therapy, or spiritual direction. Catherine had been introduced to clinical art therapy as part of her treatment in a structured recovery program. Years later, she attended a workshop with me and came back to using art as a way of expression. At this time, she felt ready to engage in a process that put the power of the image and the word back into her hands. We proceeded with care, attending to her insights as we did. In the life-dynamics journaling, pieces of the abuse experience appeared as small sparks in the foundation area of her present life. Despite the pain, she shared that the healing she had gone through allowed her to be in a specialized ministry, and she recognized that as a gift emerging from a painful history.

Deconstruction and art-journaling

Losing some long-held misconception about oneself can be traumatic, even if the misconceptions were negative. Suppose that you have always believed that you are not creative. Suddenly, revelation is shedding light on your creative spirit. How do you make room in your life for this newness, in the light of the strength of years of denial?

Sitting in meditative prayer, Bill, a busy executive, brought his restlessness into a practice of art journaling. He was not thinking of leaving his job, but was having some uneasiness about the ways in which he was spending his time. He held out the entirety of his tasks, and opened to the possibilities that might be waiting for him there.

Art-journaling invited him into his history. His love of writing emerged. He experienced a sense of loss that he was no longer spending time with that particular gift.

> In my drawing, I produced an image of a person sitting in meditation much as what I was doing. Around the figure were emanating lines. They reminded me of the lines you see in cartoons when the illustrator wants to signify sound. The next drawing that followed rapidly was of a bell ringing. I smiled at the image. It brought a

feeling of delight. My written journaling turned into a poem. I can't remember how long it had been since I had written a poem. Suddenly the missing piece became clear. It was important that I not deny my gift of writing. I felt no need to change my work but was challenged to find ways to include creative writing in the midst of what I am already doing.

Bill's restless experience of loss led to a spark of illumination.

Illumination

Illumination is not necessarily the same thing as enlightenment. It is something that happens when we least expect it. Illumination gives us small glimpses of light, a brightness that helps move us from one step to the next.

Moments of illumination can encompass discovering grace, getting an insight, or finding perspective. Illuminations scatter small sparks along your path. Illumination sounds momentous, but the experience is fleeting. Some darkness moves aside and dazzling points of light break through, showing you a tiny fragment. These glimpses are just enough to stir your spirit.

Sometimes you find an answer; more often, some perspective for the continuing walk is revealed.

Getting clarity

Illumination will be different for each person. For one, it is the ability to move from here to there in a situation. For another, it is the gift of relief that is unbidden. Although illumination is often the result of hard work, the timing of its appearance is serendipitous. As you return to or revisit important themes in your own journaling, you may identify experiences of illumination. Being faithful to a feeling of gratitude has its roots in illumination.

Sometimes illumination arises from a darkness that you were unaware of until it moved aside.

I was attending a poetry workshop. The facilitator had arranged photographs on a table. He directed us to choose one, spend time with it, and let it lead us into writing a poem.

I chose a close-up photo of a conch shell on the beach.

Figure 7.1 Pen and ink drawing of a shell lying on the beach, "her spiraled inner emptiness concealed"

As I began the exercise, I found myself in a familiar process. I was gazing at an image. The quality of my gazing, in relation to a current life concern, allowed an insight to arise. Framing the insight in poetic language forced me to be concise. The result was a poetic expression that contained some important distinctions.

All of the elements of an art-journaling were present: the image or non-verbal expression, the gazing that allowed freedom, and the written response. An ongoing "noticing" allowed the process to reveal wisdom to me at a transitional time when I was seeking perspective. Here is the poem that emerged.

Reflections on a photo of a conch shell in the sand

This is not the solitude you seek:
Not this solitude of shell,
Lonely-sitting on an open stretch of sand
Her spiraled inner emptiness concealed.

This is not the solitude you seek:
To be reflector or refractor of the light of sun each day,
The glow of moon
Receiver of each passing person's shadow
Victim to their footfall
And to the shifts of sand their heels make.

This is not the solitude you seek:
To be scrutinized and stepped around
Some shell-collector's food,
To lie immobile with no hint of rest
This is not the sabbath space you crave.

But listen!
When this ancient seaform
Lived apart on ocean floor
Cool and hidden, filled with life
A shelter for a creature with great eyes and open senses

When this shell, privy to the secrets of the depth of sea,
Neighbor to the silent swimming of an older world,
When this creature-cave breathed water
With the salt of tears,

It knew a solitude beyond the singing
Pulsed in swells of coral exhalation
Lit with mystery life
Etched by generations' wisdom

This, isn't this
The solitude you seek?

The choice of the image, the gazing, and the free writing partnered to produce a glimpse into the nature of a particular kind of solitude. It is this and not that, said the poem. It is a quality, not just a state of being alone, but one of being connected to deeper threads of life. It is not an experience of unprotected vulnerability, at the whim of others' activities. Prior to engaging in the poetry exercise, I was uneasy about this invitation and did not know why. The wisdom of the image, and the

distinction glimpsed in the poetry, shifted my perspective and allowed a bright spark to illumine my decision to seek solitude.

Delayed illumination

Barbara did a very quick journaling with pastels. The figure was bright white; the background was a deep red color.

> At the time of the drawing, my attention was focused on the elements that made up the vertical space. The form reminded me of a white flower. A week later, as I reflected on recent events, I saw the red backdrop clearly, and realized that it was the externalization of a strong feeling. I was leaning up against anger! It was not a feeling I had acknowledged when I did the art-journaling that "looked like a bud." My reflective gazing on the product drew me into a deeper honesty about a situation and my own response to it. I took time then to do some written journaling that concretized the insight. A new invitation to prayer opened up as I "lived with" this seemingly simple image.

Figure 7.2 This dark background shape yielded significant information, but not right away; the art-journaler "noticed" it several days later

One year I presented a workshop entitled, "Healing our Stories in the Creative Gaze of God." One theme directed the participants to recall a time when they experienced being devalued, and to take that experience into a prayer of art-journaling. As they drew and wrote, they could invite divine Creativity to gaze with them.

After completing the prayer, Judy Bowers shared this profound example of illumination.

> I am an ENFJ (extrovert, intuitive, feeling, judging) on the Myers Briggs Personality Inventory and had often felt devalued by my typological opposite – an ISTP (introvert, sensate, thinking, perceiving) friend. In praying with this feeling, I represented it quite literally – poor innocent me, the ENFJ, strong but small in soft pink, at the lower right hand corner of the page completely overpowered by the ISTP in large, bold red to the upper left, completely dominating me. As I was drawing I added pejorative arrows at the base of each letter of the ISTP as the feeling of being devalued grew stronger. As I drew I was really feeling the heat…hurt, rejected, beleaguered, attacked, small, out-of-control…and I felt called to add black tips to further emphasize how painful this felt. Then it was time to pray with the drawing.
>
> As I gazed, I suddenly felt compelled to finish the drawing in a way I would never have imagined. I noticed all of the heat was directed at the ENF but my J was free and wanted to act on my discomfort. Using that soft pink crayon more as a weapon, I fiercely extended the tail of the J upward above and beyond the ISTP and then drew sharp arrows of my own pressing hard down on the ISTP. I added orange for emphasis and my own black tips to boot.
>
> Almost instantly Wisdom was revealing how I too participate in the cycle of devaluing, how when I am feeling out of control my J can call me to some act of retribution, that I too am not so innocent as I would have liked to have thought, that I too am quite capable of participating in the destructive act of devaluing others. I was called to reflect on alternative, more life-giving ways to respond when I am feeling devalued rather than contributing to this deadly cycle.
>
> Prior to this experience I had a daily practice of art-journaling but rarely had such a clear and instant insight show itself. I shared the

experience with my ISTP friend and at some level it has been life-changing for both of us in ways I would never have imagined and for which I am very grateful.

Figure 7.3 Judy Bowers' example of her ENFJ art-journaling process during which the J rose up and "arrowed" the seemingly more dominant ISTP

Illumination and healing

Illumination can occur in relationship to any core theme. The focal points of the life-dynamics exercise, change, growth, and healing, could also

facilitate a direct expression of illumination. Continue to be mindful of their particular energies as you work.

A season that invites you into healing might be connected to glimpses of illumination. Discernment or resistance can also yield healing as an outcome. Pay attention to the dynamic of healing if it manifests as a call from any of the core themes.

Look for connections in relation to healing and illumination. A simple example of this might be: "In this particular theme, I identified blue as a healing color. I want to look back at other works to see how I used this color, before I consciously identified it as 'healing.' Does its use in my other drawings have an expanded meaning for me now?"

The images, the colors, and the parable ways through which you have utilized the formal elements of art and design will continue to speak. You can live with them, and in a week from now, or a month, or a year from now, they may have something else to reveal.

Doing art-journaling with any kind of regularity teaches you, in the most direct way, about the universal attribute of creativity that everyone shares.

Principles of Design
and the Creative Process

Whether you are working with a core theme or moving along with the questions of your everyday journaling practice, you are now well acquainted with the elements of design. You recognize them in the vast landscape of your art-journalings. You greet lines, shapes, and colors in your interaction with the natural world. You will not be surprised to know that design elements are governed by principles.

All works of art manifest *principles of design*. You will find these principles in your visual art-journaling, but you will also find them illumined in your own life. You might initially identify them in examples of fine art, but you will soon know them as manifestations of the inner wisdom that you seek in your day-to-day reality.

Balance is a principle of design. *Movement, rhythm, contrast, emphasis, pattern*, and *unity* are the other principles that underlie works of art, and hold aspects of creativity together (Crystal Productions 1996a, b). These principles shine forth in the art-journalings that you have been creating. They are also present in your life, which is the greatest work of art.

Balance

Balance is a familiar concept. It is a standard of essential significance. Parents want to witness the moment that their child attains vertical balance, taking his first step. There is an innate sense of what an important event it is when the child learns the complex arrangement of elements that allows him to move forward in the world. Finding the balance in riding a bike, in skating, skiing, doing a cartwheel, and conquering a sport marks other milestones. Somehow the body learns, and the mind

and spirit cooperate, to create these precise movements of freedom and beauty. Balance is inside us, as well as external. Individuals speak of trying to maintain balance when many things require attention, and it is difficult to keep priorities in their proper place. When you have encountered aspects of the art-journaling practice that have felt unfamiliar, they have been referred to as "throwing you off-balance."

You can consider balance and the other principles of design as they might manifest in the greater artwork of your life. Balance is sometimes a criterion, a way to decide whether to do something or not. It is your right presence on the earth, an indicator of standing firm on your own two feet.

As visual expressions, your art-journalings have been saying something about balance. Balance is the first principle presented in the *Elements and Principles of Design Workbook* (Crystal Productions 1996a).

Balance refers to the distribution of visual weight in a work of art. It is the visual equilibrium of the elements that causes the total image to appear balanced. Balance can be either symmetrical or asymmetrical in a work of art.

Symmetrical balance is the type with which you are probably most familiar. One side mirrors the other side. Sections are equal. "In *symmetrical* balance, equal elements are equally divided on each side of a vertical axis. In *asymmetrical* balance, elements are unevenly divided, but are balanced according to visual weight" (Leland 1990, p.66). In asymmetrical balance in a painting, one small intense color can balance a grouping of less intense and larger things. When I look at the way balance is expressed in a work of art, it is very different from my one-dimensional concept of balance. A small intense color will balance a larger subdued color. In your life then, perhaps your enthusiasms, even if they override most of your other activities, can reflect a certain kind of balance.

When you think of the parable elements of your life, perhaps there is a small but intense aspect that balances out the larger, grayer parts of your life.

A small, irregular shape will balance a larger, simple shape even if it is the same color, value, or texture. Something unique may be a place to which you can give more concentrated attention, and still be in balance.

There are times in our lives when this asymmetrical balance is at work. At certain times in our lives, one intense aspect must balance other less intense, but larger, aspects. As you develop trust in your ability to

honestly gaze at your life as a work of art, you will develop truth, not excuses, and know in an intuitive way the balance that yields life and not exhaustion. What a wonderfully freeing way to consider that perhaps life is, indeed, in balance despite the lack of obvious symmetry.

Balance can be radial. Balance can occur through an overall pattern. How do these types of balance appear in works of art?

In radial balance, all elements radiate out from a central point. When your life flows from a central value, you are expressing balance.

In a work of art, the presence of an overall pattern can balance it visually. In the overall pattern of your life, something that influences and overrides every aspect of your life, a pattern of value or behavior, can be the balancing principle of your life as a work of art.

Art-journaling and balance

It can be a significant art-journaling exercise to consider the ways that balance expresses itself in your life. How do you become more sensitive to places of imbalance? What does it look like to learn through places of balance, to learn through places of imbalance?

Figure 8.1 Pen and ink drawing of balance, both the design principle and the experience

Movement

Movement is a principle of design. It tells the art-journaler about dynamic and static places in art expression and, subsequently, in life.

Movement in your life as art happens on every level: body, mind, and spirit. Physical movement takes a person from here to there. Movement is a way to pay attention to change and respond to discernment. You need good physical movement and flexibility for health. You cultivate sensitivity to movements of grace and attentiveness to actions of intuition. Stillness comes out of movement, and is a balance for your artful living.

When you look back at your art-journalings, you may see how your compositions express movement or stillness. Notice if the particular expression of dynamism is congruent with your life.

Visual movement directs the viewer through a painting. A balance of movement and stillness exists in all works of art, in dance, in music, in painting, in sculpture, and in literature. Shapes and colors move the eye most easily through the work. Lines provide visual passage, or linkage. Your eyes follow the edges of darkness or edges of light. Visual movement leads your seeing through the work, to a point of focus.

Horizontal, vertical, and diagonal are the three main types of visual movement. Look at your work for horizontal movement. It usually conveys a calm or restful sense. If you employ vertical movement, you may be expressing a feeling of firmness or stability, or even growing. Diagonal movement frequently gives the feeling of action and swiftness.

To be artful, you need to encompass an entire range of movement. All of the contours, the colors, and the values of your life, lead to focal points.

An artist or viewer can move into a painting through a one-point perspective. Your eye is pulled into the background through the use of lines that converge inward. In Byzantine art, the movement is from the picture plane to the person, and you are drawn into mystery through the movement of grace in the glance.

Stillness and movement are on a continuum. Spend some time seeing stillness, especially in nature. Then notice the tiny aspects that initiate movement, and what that movement looks like. A leaf curls in the wind. A flower withers. There are ripples in a still pool of water.

In art, design elements go together to create the perception of movement. The way color is used can move the eye around the page. Use

of horizontal lines keeps the movement still, while vertical and short choppy lines can create much movement. Look anew at Figures 4.4 (p.79) and 4.5 (p.81) in light of the principles of movement and stillness.

Life is movement. Watch a breeze move grasses. What are you seeing?

Consider the vertical movement of standing firm. In what areas of your life are you being called to that?

Oblique movement, or diagonal lines and shapes, create tension. Where is the creative tension that is leading you toward fullness of authentic life? Use some aspect of diagonal movement in your art-journaling to express this.

Figure 8.2 Photographic example of line and movement, space, value, shape, and perspective. What else do you see?

Look back at past art-journalings. Through the use of art elements, what movements can you now identify? What do you see when you search out movement in space, line, color, and other elements? Do some written journaling to focus this.

What other movements are being expressed through the aspects and elements in your life? Probe the question using art-journaling.

Rhythm

Rhythm is the repetition of visual movement of the elements: colors, shapes, lines, values, forms, spaces, and textures. Movement and rhythm work together. As you gazed at your art-journalings for movement, you may have noticed elements in the composition that you would term "rhythmic." Certain elements, when used together, might set up a beat and produce a rhythm in your artwork. In your life of art, you begin to notice if the repetition of elements in your everyday life, or in your history, seems to set up a rhythm. These repetitions of situations or themes call for your attention.

Identifiable rhythms in a work of art are regular, irregular, staccato, and progressive.

- Regular rhythm is the repetition of the same elements in regular sequences.

- Irregular rhythm is a repetition of elements without any exact duplication.

- Staccato rhythms are repetitions that are abrupt and change frequently. They often seem to be short bursts of energy in a painting (Crystal Productions 1996a). Times of discernment in your life might be places of staccato rhythm. Decision points or quests for clarity in a situation might find you utilizing a rhythm with short bursts of activity and energy.

- Progressive rhythms are those in which the elements change size as they move across space (see Figure 8.3). Viewing a fence as it recedes into the distance gives you the experience of progressive rhythm. On your next walk in nature, notice what rhythmic patterns greet your eye.

What are some rhythms at work in your history? What are the rhythms that have changed you, slowly and deliberately, or in a great rush of surprise? What is the rhythm of the wisdom in your life? Can you use the elements of line or of color to image that rhythm?

Contrast

Contrast plays an important role in our art and in our lives. It is at those places of greatest darkness that illumination occurs. At the place of darkest dark, the light in contrast is the most noticeable. It is this way in our lives. Look at your past art journalings and notice the places of greatest contrast. Grace is waiting there for you.

Figure 8.3 Notice how the repeated shapes set up a rhythm that unites and energizes the design quality of the photograph. What else do you see?

Contrast is manifest in the differences in values, colors, textures, shapes, and other elements. Contrasts create visual excitement.

Notice the drama when two pure complementary colors are placed side by side. See areas that combine textural contrasts. When smooth

places are put in contrast to rough areas, it draws your attention. So it is with life when the smooth and the rough come into close proximity!

Where are the areas in your life of grace that exhibit contrast? In what ways are you led to discover the positive dynamic in contrast? How do you hold up places of conflict, to see instead the beauty that contrast can affect? How do you image the edges of dark and light in your experience, using line, and color, and shape, to help you to visualize this reality? Spend some time contemplatively gazing at Figure 4.3 and notice the edges of revelation and inner spaciousness that darkness and light can facilitate.

When you look back on your history, you may be surprised to discover that it is frequently the seasons of conflict, and places of contrast, that yield your greatest learning.

Emphasis

Emphasis is used to create a focus. You can emphasize color, shapes, or other art elements to achieve dominance.

Color dominance is a way of emphasizing a color family in a painting. If you look back at your work, you may notice that, with certain themes, a certain color dominated the journaling. Color played a special role in the Dynamics journaling, when you chose a color to signify healing. Look back on your history of journaling for any insights into your use of color dominance.

Visual emphasis can be achieved by a variety of ways. Various kinds of contrast can be used to emphasize a center of interest. If something is isolated, the visual emphasis tends to go there. Emphasis is on the element that is different. Emphasis can resolve conflict between elements and restore unity to designs.

When you engage in art-journaling, sometimes the emphasis seems to be on the theme. If you look at the design, you will discover emphasis in the arrangement of elements and the way they call attention to something. In any of your art-journalings, did you use design elements to create emphasis on the most important aspect of your work? To what does your journaling call attention? To what does your life call attention?

Does the element that rises in dominance in your life come from your deepest values? Are you being led to allow other elements to rise into a

position of dominance? In your life, what is the place of focus? How can you communicate your main life-focus through color, value, shape, and contrast?

Pattern

Patterns are familiar companions in the art of our everyday lives. As a principle, a pattern is a manifestation of repetition. You experience patterns of activity and of behavior. You examine life periodically to see if the patterns of your life add to truth and beauty. Patterns are the planned or random repetitions that occur in nature and in your life.

Art design uses pattern in recurring art elements to enhance surfaces of paintings or sculptures. Patterns that occur in nature exhibit unique and exquisite beauty; artists use similar repeated motifs to create pattern in their work. Pattern increases visual excitement by enriching surface interest.

Is there anything in your life that is asking for pattern? What are the significant times in your life when you experience anew a certain shape, line, or color? How often does this happen?

Is there any ache to let go of pattern? What are your life-shapes that occur over and over again? How would you image that?

Through what patterns has Wisdom manifested her work in your history? What are your consistent choices? What are your inconsistent choices? What are those places that interrupt repetition? Where is the grace in both of these dynamics? What does this look like?

Unity

Visual unity is one of the most important aspects of well-designed art. Using a dominant color scheme, or employing an overall surface treatment, creates a strong sense of unity.

Unity provides the cohesive quality that makes an artwork feel complete and finished. When all of the elements in a work look as though they belong together, you have achieved unity.

For your life as art, this is the work of a lifetime. You gaze at the elements of your life and notice what seems to fit, and what seems to be incongruous. Through artful living, faithful discernment, courageous choosing, and graceful surrender, the work of art takes on the glow of

unity. This is your quest, and the path that opens up before you, as you create the art of life.

The design principles of balance, movement, rhythm, contrast, emphasis, and pattern work together to create unity. The principles are present in a successful design, and in the design of your life.

Do a pair of art-journalings, addressing the theme: "What does my desire for unity, and my desire for inner wisdom look like? How are those images similar? How are they different?"

Principles and elements of art

In your attempt to express what your desire for unity looks like, you may have created a balanced (or unbalanced) art-journaling using the element of line. You may have employed the element of color to create unity. The principle of unity, and all of the other principles of art, come to reality through design elements.

You can look for the principle of emphasis through the element of shape, seeing which shape is the larger or more detailed. You can create the principle of pattern through the elements of line or texture. The principles of design take you a step farther in the vocabulary of visual language. Even more, they employ a breathing place of intuition, a combination of what you learn through definition, and through "gut reaction." You become uneasy in the presence of disunity. You feel restless when the visual rhythm is inconsistent. Your inner seeing works in combination with your physical vision as your facility for this visual language increases.

You will want to learn more about these principles of design. Look in books and read more about them. See them in nature. Continue doing your art-journaling with a deeper sensitivity to the principles that hold the creative process together, and that express it in an eloquent way.

What elements and principles are at work in this sketch in Figure 8.4 (p.146).

Creative processes

Your ongoing dialogue with the elements of art, and the principles of art, gives its own perspective to the creative process. All creative processes hold things in common. You have experienced these aspects in a concrete way in your work with art-journaling, and in your presence to your life as art.

Figure 8.4 What elements and principles of design speak to you in this drawing?

A subjective sense of oneness is the felt experience of the principle of unity. When you are caught up in a creative act, you become aware of this single-minded congruence.

You experience it as a sense of satisfaction and completeness. In your life of art, you move toward congruence and a sense of authenticity. This feeling of oneness is an aspect of all creative processes.

The experience of mystical sight, inner revelation, insight, or sixth sense can come into play in a creative moment. So can the sense that time expands, or is compressed. This *Kairos*-moment (see page 25) characterizes creativity and is a phenomenon with which you are familiar from your work with art-journaling.

Forgetting and remembering

Forgetting and remembering are dynamic polarities in the realm of creativity. In a creative practice, there are rules to learn and principles to master. However, if you do not then "forget" these rules, you never quite reach art. This forgetting is not so much a "non-remembering", as a surrendering. The truth emerging from the process leads you; you let go of possessing the "right way" in order to move from craft to art.

In an essay on art and contemplation, Joseph Pieper says that the artist is called to remember (Pieper 1990). In remembering, you are inserted into tradition and history, into the archetypal images, the sacred dances, the holy words (Hieb 1992). Creative processes are inherently healing, they *re-member*. They have the potential to bind up wounds and bridge gaps. Remembering is a deep well in the creative process, an underground river that restores and nourishes.

Harmony is a quality associated with the creative process. It is closely related to the principles of balance and unity. Harmony implies a felt sense of tranquility. A harmonious picture emphasizes similarities in relationships. When experiencing visual harmony, one might be seeing close values or colors, and similarity of lines, shapes, and sizes (Leland 1990, p.64). What is at work in your life when you are experiencing harmony?

Can you sense moments and movements of harmonious design as you gaze at your life, and at the life of others in your circle of concern? How might you image that?

Compassion

Authentic creativity ultimately yields a felt sense of compassion, as well as concrete manifestations of compassionate action in the world. Your presence to the uniqueness of life, to real limitations, and to unique giftedness, yields a compassionate stance. Your awareness of wholeness, and the interconnectedness of truth and beauty, yields compassion. Your gazing yields compassion.

When you truly see, when you remember, when you are startled into the mystical experience of oneness, you understand at the level of heart; you are slowly and inexorably transformed by compassion, transformed into compassion. Compassion is one of the fruits of any creative process.

The concepts and practices of art-journaling can support you in becoming more compassionate toward others and toward yourself. It can increase your commitment to act with compassion toward the environment. An approach to eco-spirituality is deepened by the practice of looking contemplatively at nature and at all created things, looking at it lovingly until it looks back at you. As you engage in the prayer process that leads us to *see, name, and call into being*, this spiritual practice grows you into compassion.

Befriending creative process

You find creativity in the world around you. In literature, prayer, poetry, music, dance, design, relationships, parenthood, in living, working, and ministering, you will recognize aspects of the creative process.

Just as you have grown in your visual sensitivity, you will grow in your ability to notice creativity shining forth from experience, from events, from things you hear and read, from traditional stories, from sacred words and holy images. Life moments take on deeper meaning.

Beyond noticing this around you, you will find it in your own interiority, and manifest it. Wisdom invites you to show forth the light and not hide it. Let your light shine. Do not hide it from others, but more importantly, do not hide it from yourself.

Art-journaling and prayer

Art-journaling is a prayer process. It shares in the principles of mystical practice that spans traditions and ages. It can accompany any spiritual path.

The integration of visual art, gazing, and written journaling produces a spiritual discipline that weds immanence and transcendence. This prayerful dialogue combines the non-verbal Image so powerful in the Eastern spiritual tradition of icon and color, with the Word, the incarnational dynamic of Western spirituality (Burckhardt 1967).

This wedding of image and the word in a creative process is a way of revelation (Nouwen 1987). Frequently, art-journaling confirms the edge of something that you had been suspecting all along. Through it, you may catch a glimpse of the sacred power inherent in the act of creation. You experience the awe of sharing in Divine creativity.

Through your work, you have explored the potential of art-journaling to call forth words and images from your deepest self. You discovered ways of seeing and hearing with new eyes and new ears. You are gifted with a new voice, and learn at times to speak in a new language.

Faceted prayer

Prayer is sometimes a response, but more often it is a question, a blank openness into which you invite the voice of the Holy. Frequently, this open question is the starting place of the prayer of art-journaling.

Art-journaling partakes of many facets of a prism. Your own work, and these stories, have shown us a few of these facets, the sparkling diversity of prayer.

Throughout life's journey, you might experience prayer as a gathering place for your deepest being. It is a yearning toward…an act of praise…a searching in the darkness…a hurling forward of cosmic anger…a query put before the universe…a cry for meaning. It is words and silences, and the pulse beat before those words, and within that silence. It is being wrapped in the Holy, despite any awareness of that wrapping. It is a basic acknowledgment of the cycle of life, death, and resurrection in the face of mystery.

In moments of grace, prayer can be a language of revelation. Your ordinary and extraordinary life is the essential container for this revelation. You come to know this organically.

In art-journaling, life events become the place that reveals this process of becoming.

Its activity parallels holistic prayer, contemplative presence, and mystical sight. It manifests in prayers of meditation, contemplation, petition, and transformation. Included in its fruits are compassion for self, others, and the world.

The art-journaling discipline teaches us something very important about prayerfully seeking wisdom. You must begin. You launch out in faith. You do not and cannot predict the outcome. There are disappointments, as well as moments of clarity and of exultation. You are on a journey, always beginning, always surrendering, always resisting, always being carried, always being given a gift, being named as gift.

Lessons from the stories

The stories scattered throughout this work reveal aspects of *process, product,* and *way of presence,* and show us the heart of art-journaling, this uniquely human search for insight. In Sarah's discernment process, we see the effectiveness of art-journaling at a life-decision point. Phillip's story reveals a sense of deepening that called for acceptance. Cynthia's beach reflection shows us the power of exquisite listening to the ordinary in creation. My own life was influenced when I gazed at a photograph, and journaled a poetic response to an invitation to solitude.

These are all sojourns into relational prayer. Relational prayer travels in hope, into a faith that Someone/Something is the receiver and the Source.

Devotion

Art-journaling can be a tool for ongoing devotion. It may be a fitting complement to your current practice. You may add it on a regular basis as a deepening to the scripture prayer, the chanting, the centering prayer, or any other of your personal spiritual disciplines.

It can also be uniquely helpful when other disciplines fail. Joan is going through a time of darkness and dryness. The usual ways of prayer no longer hold any consolation for her. She is exhausted, discouraged, and just non-feeling. Now might be the season for her to use art-journaling as a primary practice, as an approach to the Holy that can hold the darkness and dryness until she is ready to claim them.

It is a time in Daniel's life when something extremely painful is his constant companion. Words elude him, yet he yearns for some way of being present to the greater movement of the spiritual. Using art-journaling and merely including a title or a word, rather than doing extensive written journaling, may be a way to remain faithful to the ways that life is unfolding. Later, when he is able to sustain a communication that is more verbal, the art images will be waiting for him.

Organic growth

Art-journaling practice supports organic growth. Perhaps you are basic-ally a non-verbal person, and have longed to use the power of an imagistic language in your practice of prayer. On the other hand, you are

basically a high-verbal person and want the energy hiding in your shadow to be released. Either of these dynamics can be supported in a process of drawing, gazing, and writing.

Art-journaling pushes against the edges of something in us in order to outline the contours with clarity. It is the creative gesture that presses into the clay, encountering resistance, and then lightening the touch until the congruent depth is reached. It knows that the walls of the vessel cannot be too thick, or it might explode in the firing. The pot might not have balance and harmony; it might give up its ability to be utilitarian. It also knows that the walls of the vessel cannot be too thin. It will warp and crack long before it is fired. It will dry unevenly. It will be too fragile to exist on its own. Practice teaches the art-journaler, the life-artist, about these boundaries, just as surely as the boundaries teach the art-journaler about practice.

Prayer and practice

Your art-journaling practice has led to a deepening. Since taking the plunge into the elements/dynamics duo, your insights about your own epiphany, and where grace is manifesting in your life, have deepened.

Art-journaling has the potential, as do all spiritual disciplines, to be transformative. It helps you to listen to, and to receive from, the Holy. As a spiritual practice, it partakes of rich givenness. It is a dialogue with the inner self, with nature, and creation, with your life as it manifests wisdom's creative will and design, and with the mystery and surprise of the sacred. Through it, you may receive glimpses of a revelation that wants to be seen, and heard, and known. Through it, the seeds of inner wisdom that have been planted deep within you will become manifest.

9

Inner Journeying
Ways of Working, Ways of Continuing

As a creative practice, art-journaling invites us to compassion. As a prayer practice, art-journaling invites us to compassion, and to the manifestation of compassion in service. That service is directed toward the other. It holds out healing in the face of pain and suffering. It is a faithful stance, despite the reality of horror and the unspeakable. It is stirred by our gazing at the wonders of our universe. It is the generous act of contemplating gratuitous beauty. Service through compassion is also a gift that you must lavish upon yourself; you are a unique work of art.

Working with others

Art-journaling is a meditative practice for ordinary times and extraordinary moments. It has proven a helpful tool for people who are seeking the presence of the Holy, especially in times of discernment, grief, despair, chronic pain, deep gratitude, and other situations when mere words seem inadequate.

Many factors in our society, and in our world today, make it difficult to enter into a prayerful place of simple presence. We have lost opportunities to interact with the natural world. Development has destroyed vast expanses of the very beauty that speaks to us of the Creator. Time is at a premium. Silence is difficult to find. Both interior and exterior space eludes us. The careful practice of art-journaling can reconnect us to the mystical sense of our longing.

Why art-journaling now?

You are affected by the growing technology and the immense advances made in communications. At this new place in the world, you receive

instant information, with little time to digest it. Images of horror and destruction can be beamed into your daily experience in regular doses, and with unprecedented and shocking immediacy. These violent, visual encounters call out for healing. As a member of the human family, you need ways to express your longing and your pain in the midst of tragedy. You need ways of strengthening and celebrating the resilience of the human spirit. In grief, oppression, shock, and overwhelming pain, as well as in times of indescribable gratitude and awe, art-journaling can facilitate authentic expression. These are some of the huge moments when human ways are challenged, and you can sink deeper into the world of silence and solitude, or commit more deeply to the world of imagery and community. The instrument of art-journaling can give you some language.

Compassionate action

The way you work with others is a practical outcome of the compassion derived from the creative process. Early on, I warned about learning art-journaling with the sole agenda of giving it to someone else who "needed" it. I encouraged you to do it for yourself and, in the doing, art-journaling would become a part of you. From that authentic understanding, you can give from your own experience, and in your own unique style. That will occur, informally or in a structure, as you move forward on your journey.

When I work with the students studying spiritual direction, my class includes a combination of meditations for their own prayer, and modeling the spiritual direction relationship with another. Since these people are studying to facilitate this work in others, there are a few guidelines I offer. It may be helpful to your own service situation. As someone facilitating art-journaling, what I would not do is:

1. tell someone what his or her drawing means
2. interpret/analyze
3. be the expert
4. take advantage of the vulnerability of the situation.

What I would do is:

1. try to be visually sensitive

2. try to see and listen contemplatively

3. let the colors, shapes, space, line quality, intensity, etc., speak to me

4. be attuned to the feeling level

5. resist resting in content only

6. ask questions with gentleness

7. be silent, rather than force a verbal response

8. reverence the icon-space between the directee, the journaling, and me

9. dedicate my intuition to the spirit of Wisdom

10. look at nature, fine art, and creation to continue developing the richness of seeing

11. seek wholeness – in the journaling, in the directee, and in myself.

This is an organic and growing list. It is simple and speaks to human relationships. When we discuss it in class, it is altered and expanded. It is based on the value of presence, in staying out of the way, and in giving over the authority to the person. Compassionate action seeks wholeness. It gazes with creativity. It speaks with life-enhancing words. It flings more beauty and truth into the universe, stirs the spirit of Wisdom, and sends forth a blessing that endures.

Art-journaling and spiritual direction

When I gaze at an art-journaling in a spiritual direction relationship, I stay in a contemplative space, receiving from the image. I refrain from an attitude of interpretation, not commenting on any projected meaning; rather, I allow the image to reveal its richness. The goal of spiritual direction is presence to the other and to the Holy. Art-journaling can facilitate this presence in a unique way.

When you find yourself in a relationship of service, some perspective on art-journaling practice will be helpful as you discern the way of bringing compassion to that situation.

Art-Journaling and workshop participants

A young woman comes to our Wellness Center for nutritional counseling. As a pastime, she draws tiny pencil sketches. She does them in the form of cartoon boxes, and they tell little stories about the everyday life of her fantasy characters. These are whimsical inventions that go through ordinary things in a humorous way. Knowing my interest in art, she shows them to me when she visits the Center for her appointments.

She decided to attend an art-journaling workshop, but wanted to stay with her material of choice, very sharp pencils on white paper.

Figure 9.1 The type of art produced by "Becky" shows a connection to her dialysis experience. The vein-like double lines and her insistence on very sharp drawing tools were remarkable

We did the life-elements drawing and I suggested, as I always do, that the participants tend toward abstract expression, rather than create a drawing with realistic elements. Becky went away and tried very hard to accomplish a journaling with her pencils. She ended up with an elaborate cartoon series of her life history. As a young girl, she had to undergo dialysis. Her life was peopled with adults at a time when she would normally be playing with children. She drew frequently in that circumstance, and it was then that she developed her unique style. In this workshop, she considered for the first time that her visual world of thin,

sharp, double lines could possibly be a child's awareness of veins. The sharp pencil is like the experience of needles. Her everyday stories, laced with humor, are ways to go on in the face of pain that she would like to escape. Even the boxes of cartoon space gave structure and form to an otherwise unbounded feeling.

How should she move forward from this insight in an artful way? We gazed together and formulated a variety of alternatives.

She could delve even deeper into the experience of sharpness, choosing tools that would carve designs onto linoleum blocks. She might take up woodcarving, or use a needle tool to texture clay surfaces.

She could learn more about the body's structure through an anatomy or life-drawing class.

She could move in the direction of flow, learning the properties of watercolor. She could identify healing colors and fill the drawn channels with pastels. Her color experience could become more direct, using finger-paints.

She could use clay to experience its soft, yet firm and reliable, qualities.

At any time, she could return to her practice of sketches with awareness and appreciation. She could continue to develop the stories and appreciate the tool that helped her at a difficult time.

The workshop structure gave me the opportunity to work with Becky and her unique history. Her goal had been the exploration of diverse art experiences. An unexpected result was an interior awareness of the deeper meaning behind the drawings that she had done for years. I accompanied her and gazed, listening to her insights and experiences. Together, we brainstormed alternative art activities, but these are just "maybes" and "what ifs." She will experiment with them if and when that seems right. She now has the openness to recognize signs directing her to move toward inner wisdom.

Initially, it was not important for her to understand what her art materials and design elements were saying. Once she did, her interest was piqued to move out into other art experiences. She was delighted to realize how, even as a young child, she had set up for herself a wonderful structure for coping and expressing. She left the workshop with some possible creative outgrowths, and a confirmation that her own inner wisdom had served her well.

Unique outcomes

Throughout this book, you have been introduced to the stories of many participants in retreats and workshops. Each story demonstrated a different outcome, based on the person's unique experience of the art-journaling process. If you find yourself in the role of facilitating such an experience, create an atmosphere in which this wide diversity can flourish.

You may be working as a pastoral counselor, ministering in bereavement, or serving in a helping relationship with the elderly. If you are privileged to gaze on another's art-journaling expression, stay in a receptive mode. If an insight or question comes, do not be afraid to share it for the person's consideration. The journaler is the authority over her work, and will hold up your insight next to her own experience and test it out.

By the same token, when working with another, do not be concerned if no insight comes. People will appreciate your willingness to wait at the threshold of mystery. This process is not about you as an expert. It is about putting the power and authority of art-journaling as a journaling process back into the hands of the participant.

Art-journaling and you as reader

The goal of this as a written work is the same. My purpose is to put the power of the process into your hands. I present tools that will empower you, not just in the art-journaling process, but also in all creative and contemplative situations. Many of these situations we have already traversed. Scan the following list and check it against your current skill set:

- seeing and noticing
- waiting in darkness and silence
- welcoming illumination
- trusting your own authority
- paying attention to holistic clues
- writing down your insights
- reading the parables in elements of design
- giving space and time for discovery

- knowing that your experience is trustworthy
- being patient – revelation is organic and evolves like we do!

Your unique progress

Creative compassion is not just reserved for your service to others. It is the gaze that you must cast on your own life. It is essential to claim your creativity, to seek your inner wisdom.

In our approaches to art-journaling, you have touched on themes specific to major movements in your spiritual life: seeking integration, engaging in discernment, identifying places of blindness, of gratitude, of remembering, and of healing. But, in the everyday, as the discipline of art-journaling has meaning for you, there are some simple and organic ways to continue.

Followings

You have already learned about continuing your work through "followings" – looking at *design elements, holistic presence*, and *content* to develop the journaling. Use this progressive way of moving from one journaling into the next for as long as it is fruitful.

You have been challenged to see if any of the life-dynamics of *change, growth* and *healing* are places calling for a more focused way of working. During dynamic life transitions, any of these themes may be requesting your attention.

You have been invited to notice if and when a core theme might be manifesting itself in your life, and you can refer to questions that will guide your movement through them when appropriate.

The importance of questions

In many of the art-journaling stories, the participants have used questions such as:

- "What would it look like if ——"
- "What does my relationship to —— look like?"
- "What does the feeling of —— look like?'

Formulating the kind of question that speaks to your present reality can be an art in itself. It may be important to hone in on something very specific in your life. Themes will emerge from everyday wonderings and worryings.

- "What does (a particular situation) look like, feel like?"
- "What would it look like if I were to let go of this (worry, concern, anxiety)?"

Questions can come from your circumstances, from your work and life situation, from an insight in nature, from a chance encounter, a dream, or any part of your life's tapestry.

At other times, the universal themes of the human condition might be exactly the right place for your journaling. "What might freedom look like?" "How might I image serenity?"

Creating the journey with questions

In this discipline, you create the journey with questions. You seek to ask the "right" one and respond using the practice of art-journaling.

Have you experienced traveling in an unfamiliar territory? You stop a local inhabitant to ask for driving directions. You have to ask the right question.

Years ago, I was with a friend visiting Ireland. We had mapped out a way to the south when we drove around an intricate intersection of curved roads, and the route number just disappeared. All signs were gone, and even the look of the terrain had changed dramatically. Panicked, we stopped and asked a tweedy-looking gentleman, "Where is Route 8E?" When he just stared back at us, we added, with agitated gestures, "What happened to Route 8E?" Still, the silent look. We began again; recounting how we had followed the signs, traveled the circle and no longer saw any signs. "Where do you want to go?" he finally asked. "Kilarney," we answered. He proceeded to give us simple and eloquent directions that took us directly to the town. We had asked the wrong question. The route number question was meaningless to him, but he certainly possessed the information that we so desperately needed. The right question, asked at the right time in our lives, especially at those turns and bends in the road, can make all the difference. However, you do not need to wait for the right question. Begin the journey and it will form out of the material of the journey itself.

Evolving themes

Themes will arise from familiar and unfamiliar sources. Begin your art-journaling with words from Scripture, sacred texts from your spiritual tradition, comforting quotations. Use poems from your history, or song lyrics that are meaningful.

Begin the day with a journaled goal; end it with a gathering of graces and insights. Do an art-journaling in anticipation of an event, or looking back at a celebration. Ask for a clue that might change darkness to clarity, or bring shape to something formless. Address themes of gratitude, count blessings, and celebrate graces.

Encounter the elements and principles

Use the exercises in Chapters 4 and 8 that accompany the descriptions of each element and principle of design. Explore line, shape, or color in an intentional way. Play with contrast, create disunity. There are times in your life when being at some comfort level is essential. Other times, situations that hold a level of discomfort provide the occasional jolt to shake you from lethargy, and propel you toward growth and discovery.

Structures

People are often surprised to hear that artists need structure in order to be creative. The nature of the structure can vary greatly, but all creative processes take place within a space that incubates, contains, nourishes, and sends forth. Art-journaling is a creative process and requires the presence of structures to bring it to its fullest potential.

Some structures belong to the very nature of the process. Other limited structures, including materials and methods, enhance and give quality to your practice.

A literal way to provide structure might be to create a shaped frame on your page and draw within that. This shape could be freeform, or you could trace a circle or triangle, and work within that boundary.

Backgrounds

Rather than white paper, use sheets of colored paper to provide a background for your journaling with oil pastels. Notice the way that the expression of something changes if it is done on black, red, green, or blue

paper. Let the colored paper act as a symbol. You frequently come to a life situation with a "background." Choosing a color to receive the expression of a certain theme can add to its parable quality.

Going back and forward

Go back and track themes that you have already used. Periodically, it is helpful to revisit significant topics which you addressed in the past.

View a completed drawing and see if it calls out for deepening. Draw it over, expanding it, and adding detail, color, and intensity. Bring it to fuller expression. Then gaze at both pictures, and do some written journaling in response to the comparison.

Revisiting with a microscope

Go back to your original life-elements drawing. All of the drawings that you do are very powerful, but often this first one holds treasures that call out to be mined. Is there any place in this first drawing, now that you have lived with it for a while, that invites further inquiry? Gaze at it as if it were under a microscope. In your imagination, zoom in on this point, and art-journal about how it looks or feels when it undergoes magnification. This approach can be taken with any of your journalings, even years after they have been done.

Process and product approaches

Create your own guided meditations using themes that stress either process or product aspects of art-journaling. In emphasizing process, you might use pastels to draw in response to a prayer of seeking. You might take a walk out in nature, or down a city street, or through your imagination and gaze receptively.

If you were emphasizing product, you would notice the outcome of your journaling, or the qualities of the symbols that you encounter on the walk. Even silence or darkness can be part of the response. With either approach, notice your own *holistic presence*, and journal about any insights around the process and product of your meditation.

Figure 9.2 This art-journaler wrote as she drew to chronicle the process. She wanted to record the order in which the visual elements entered into the design

The creative resting/creative manifesting duo

Resting in wisdom and *manifesting creativity* are two essential and complementary invitations that will accompany you as you continue this holistic journey. These integrating meditations clarify your evolving position in relationship to the rhythms of inner resting and outer reaching. Just as you used the life-elements/dynamics assessment as a base upon which to view your life, so now you can use the resting/manifesting duo to consider places of creative stillness and movement. These companion exercises focus the dynamics of holistic spirituality, challenging you to seasons of resting in inner wisdom, and of moving forward in creative manifestation. The circle and spiral are symbols for the expressive reality of this holistic dynamic.

You have already experienced that it can be helpful to engage in structured meditations. When you feel ready, you may move through the stages of the creative resting exercise to probe any invitations hidden in your current journey.

Art-journaling exercise: resting in wisdom
Supplying and settling

In your prayer-space, gather the art supplies, pastels and a large sheet of black or white paper. Trace a light outline of a circle on your paper to use as an integrating structure. Draw the circle lightly prior to beginning the meditation, or incorporate the deliberate action of creating a circle into the prayer time. You may need a template (a plate or other circular shape), or a compass to make the circle with ease.

OPENING TO THE THEME

The circle has been used in all ancient civilizations as a meaningful symbol. We find it used in the intricate decoration of Etruscan pottery, in the sacred art of India, and in designs carved in stone on Celtic prehistoric burial mounds. In primitive altars from a variety of cultures, and in sophisticated expressions in modern art, the circle takes on a mystical presence. It is a symbol in liturgical art, and can be found echoed in nature as a growth and flowering form. In psychology, the circle is a powerful tool. Carl Jung did a mandala every day in his own personal practice of self-discovery. He considered the circle-shape an archetypal presence and a symbol of wholeness.

It is very helpful for some people to use the shape of a circle in their art-journaling prayer. The circle shape may both enhance and limit your freedom of expression, or may otherwise intensify some aspect of this particular theme.

Turn your attention to the deeper presence of the Holy within and beyond you. Trust Wisdom's desire to reveal to you some small segment, some tiny aspect, some jewel of your inner self. Begin as you have been, in the context of prayer. Seek the grace to receive from the spirit of Wisdom. Come in trust, asking to receive a glimpse of inner treasures and the unseen aspects of the Holy expressed through your life.

Visualizing

Imagine that your entire self is being surrounded by light. Sense this light around you as a gentle presence. What are the qualities of this light? Spend some time deepening in your awareness of these qualities. Rest and relax into this light and allow its presence to become symbolic of Wisdom's desire to illumine. As you feel ready, slowly imagine that this light penetrates your being. You imagine that it begins to flood your brain, touching your mind, illuminating your thoughts. Slowly, you imagine it as a moving plane of light that permeates your body. You imagine it moving from the crown of your head through your entire body. Take some time to allow this process of visualization. As you do, continue to gently bring your awareness back to the realization that the light is symbolic of Wisdom.

Aware of the presence flooding your mind and body with light, you sense the reality of an even deeper place within you, your "hidden self." Imagine a dark column opening up within you. A secret garden, a hidden self awaits you as you move slowly downward, following the shaft of light. Once there, in this place of inner wisdom, rest quietly.

Posing the question

What does some tiny aspect, some texture or movement, some attribute of my hidden self look like? Reveal to me some glimpse of this inner wisdom.

Stay wrapped in this sense of being surrounded and interpenetrated by Wisdom as light.

Drawing / gazing / writing

Spend the next thirty minutes expressing or responding to this theme and visualization by using pastels and paper. Work with the colors, shapes, textures, and other elements, asking that Wisdom reveal to you some small aspect of your hidden self, some hidden treasure that seeks to be illumined.

You may choose to work within the circle-shape, or use the borders of the circle to expand outward and beyond. This particular shape has a center. Notice if that takes on significance as you gaze at your finished work.

As you bring this meditation to a close, spend some time in written journaling to clarify and further the prayer of the hidden self.

Holding to the center

As you further reflect on the prayer, consider some follow-up themes to move into a place of finer distinction.

- What does resting in inner wisdom look like/feel like?
- What is the shape of my inner journey?
- How might I image this inner garden?
- What are the holistic presences that are evoked in this meditation?
- What is the source of my centeredness?
- What is the invitation to silence, darkness, and stillness?
- Does resting in inner wisdom feel like an authentic response to my current life of grace?
- What would it look like to have more of this resting into my life?
- What do I need to add?
- What do I need to let go of for this to happen now?

Spiraling outward

Complementary to the interior state of holding to the center, you also need to pay close attention to seasons of manifesting truth and beauty.

You become sensitive to knowing when it is time to move in the direction of your unique gifts. In paralleling the organic growth of a seed, at the acceptable time (and not before) there comes a time of flowering. Fidelity to all of the seasons allows you to be single-minded about the seasons of manifestation. The Manifesting Creativity Meditation helps in discerning when, where, how, and why it is essential to let your light shine.

Art-journaling exercise: manifesting creativity

Settling

Sit with your hands open and cupped. Close your eyes and move to that deeper place where Wisdom resides, that place of divine creative spark.

Visualizing

Imagine that the space that your hands cup becomes heavy, and begin to notice there a darkness that is rich and mysterious. Somehow, this darkness is related to your creativity. Gradually, as you breathe gently, this cupped open space that your hands hold begins to change. Perhaps it begins to take on a slight hue or a deep color. Perhaps it becomes lighter or denser. Perhaps you sense it becoming larger, or smaller, and more concentrated. Perhaps you have a sensation of warmth or coolness there. Allow this sense of mystery to grow. Become aware of it as energy. Sense this energy growing from your hands and flowing all around your body. Take a moment to sense this expanding sensation. Now begin to breathe in this energy. Imagine it moving in on a breath and swirling behind your eyes, your ears, your nose, and mouth. Imagine it touching your inner seeing, inner hearing, inner smelling, and tasting. This energy touches that mysterious and miraculous organ of the brain. You allow this creative energy to soak, and expand, and rest there for a moment. With your breathing, you imagine this held energy moving down into your deepest body, into your neck and shoulders, softening the muscles and allowing expansion of the cells. Breathing gently, you imagine this creative energy moving from your shoulders all the way down your arms to the tips of your fingers. It fills the trunk of your body, touching the heart center, the solar plexus, the root chakra, powerful places of energy, potential, and life. As you continue to breathe in gently, you imagine this energy continuing to move through your body, moving through your thighs, calves,

and to the soles of your feet. Sense yourself grounded as you complete this visualization.

Staying wrapped in this rich mystery of your own creativity as a gift within you, prepare to respond to this question using either pastels or clay.

Posing the question

Where are the places in my life where the gift of creativity is being formed, enhanced, strengthened, clarified, or healed?

Drawing/gazing/writing

Answer this question using color, line, shape, size, emptiness, fullness, stretching, breaking, or pulling apart. Take some time to notice what happened interiorly and exteriorly. What did the material tell you? What did you tell the material? When, and at what point in the exercise, did you notice a shift in your energy? Did you learn something new? Did you catch a glimpse of the edge of revelation?

Write about whatever draws you. In this meditation, you tried to clarify in what ways your unique creativity is at work within and around you. A follow-up series of questions can focus the range of this creativity in service.

- Where and in what situations is my gift of creativity manifesting itself?

- What do I need to increase for this manifestation to become more authentic, to become stronger?

- What do I need less of as I move in the direction of my unique giftedness?

- What do I need to let go of in order to hone the dynamic of creativity in its most essential expression?

Let the expansive potential of these and other questions challenge, focus and inspire you as you cultivate your practice of art-journaling in the soil and shadows of the days ahead.

Nudgings

The importance of nudges

We circle around to the point at which we started, resting in wisdom, and spiraling out in creativity. At the end, you are left with what you had when you began this book – a nudge. The nudge has yielded a journey, and has opened you up to questions, some of which have yielded insight, others of which have spawned the next set of questions. Some nudges lead you deeper into the art-journaling journey. Others might be pointing the way toward other serious, or whimsical, lanes of travel.

You are ever encouraged to revisit, make space, and notice. Periodically go back and redo the life-elements and life-dynamics exercises. Take the opportunity to compare the last one you did with your current assessment, noticing the expressive elements and principles of design that are waiting there for you. What has stayed the same, what has endured? What has changed? What has disappeared altogether? Write about and notice these manifestations of grace in your becoming.

Pay attention to the illuminations shining forth from the creative resting/creative manifesting invitation. Trust the longing and the learning, and do not miss those tiny moments when the veil moves aside and you catch a clear glimpse of your own unique "what next" on the journey.

Movement and stillness

Your relationship to the tool of art-journaling can enhance and express the treasures of a spirituality for our time. Elements of this holistic practice move you and our earth toward healing and empowerment, toward reconciliation, reunion, and communion. The creative tension in the polarities of darkness and light, emptiness and fullness, image and imagelessness, is the dynamic that will sustain the present as you move forward into a future of hope.

Jealously guard the space that you have claimed to play by the side of Wisdom. Walk in the garden of nature, and down the streets of your discovery. And in those seasons, when you are able, notice the moon shining in the daylight and know.

References

Burckhardt, T. (1967) *Sacred Art in East and West*. Louisville, KY: Fons Vitae.

Cheatham, F.R., Cheatham, J., and Haler, S. (1983) *Design Concepts and Applications*. Upper Saddle River, NJ: Prentice-Hall, Inc.

Corvo, J. and Verner-Bonds, L. (1998) *Healing with Color Zone Therapy*. Freedom, CA: The Crossing Press, Inc.

Crystal Productions (1996a) *Elements and Principles of Design Posters: Teacher's Guide*. Glenville, IL: Crystal Productions, Co.

Crystal Productions (1996b) *Elements and Principles of Design Posters: Student Guide* with Activities. Glenville, IL: Crystal Productions, Co.

de Sausmarez, M. (1964) *Basic Design*. New York: Reinhold Publishing Co.

Dillard, A. (1974) *Pilgrim at Tinker Creek*. New York: Harper and Row.

Dillenberger, J. (1990) *Image and Spirit in Sacred and Secular Art*. New York: Crossroad.

Dunning, S., Lueders, E., and Smith, H. (eds) (1966) *Reflections on a Gift of a Watermelon Pickle*. Glenview, IL: Scott Foresman and Company.

Dunn, C. (1995) *Conversations in Paint*. New York: Workman Publishing.

Edwards, T. (1987) *Living in the Presence*. San Francisco: Harper and Row Publishers.

Faulkner, R., Ziegffeld, E., and Hill, G. (1964) *Art Today*. Austin, TX: Holt, Rinehart and Winston.

Fitzgerald, W.J. (1998) *A Contemporary Celtic Prayer Book*. Chicago, IL: ACTA Publications.

Fincher, S. (1991) *Creating Mandalas*. London: Shambhala Publications Inc.

Forest, J. (1997) *Praying with Icons*. Maryknoll, NY: Orbis Books.

Fox, J. (1995) *Finding What You Did Not Lose*. New York: Jeremy P. Tarcher/Putnam.

Franck, F. (1973) *The Zen of Seeing*. New York: Random House.

Franck F. (1982) *The Supreme Koan*. New York: The Crossroad Publishing Company.

Hieb, M. (1992) 'Spiritual Direction as a Work of Art.' Keynote Address: *Spiritual Directors International Symposium*. Chestnut Hill, NJ: Lourdes Wellness Publications.

Hieb M. (1996a) 'Icon-space and Spiritual Direction.' *Presence: An International Journal of Spiritual Direction 2, 2*, May.

Hieb, M. (1996b) 'Spiritual Direction and the Prayer of Art-Journaling'. *Presence: An International Journal of Spiritual Direction 2, 1*, January.

Holmes, H.N. (ed) (1999) *Nurse's Handbook of Alternative and Complementary Therapies*. Springhouse, PA: Springhouse Corporation.

Johnson, W. (ed) (1973) *The Cloud of Unknowing*. New York: Image Books.

Keck, L.R. (1992) *Sacred Eyes*. Indianapolis, IN: Knowledge Systems.

Leland, N. (1990) *Creative Artist*. Cincinnati, OH: North Light Books.

Leslie, C.W. and Roth, C. (1998) *Nature Journaling*. Pownal, VT: Storey Books.

Lowry, B. (1963) *The Visual Experience*. Upper Saddle River, NJ: Prentice-Hall, Inc.

May, G. (1977) *Simply Sane*. Mahweh, NY: Paulist Press.

May, R. (1975) *The Courage to Create*. New York: Bantam Books.

Matthews, G. (1963) *Byzantine Aesthetics*. London: John Murray Ltd.

McCreight, T. (1996) *Design Language*. Portland, ME: Brynmorgan Press.

Merton, T. (1955) *No Man is an Island*. New York: Harcourt Brace Jovanovich, Inc.

Moorhouse, P. (1990) *Dali*. London: PRC Publishing Ltd.

Nouwen, H.J.M. (1987) *Behold the Beauty of the Lord*. Notre Dame, IN: Ave Maria Press.

Pieper, J. (1990) *Only the Lover Sings: Art and Contemplation*. Fort Collins, CO: Ignatius Press.

Teilhard de Chardin, P. (1961) *Hymn of the Universe*. New York: Harper and Row.

Trungpa, C. (1996) *Dharma Art*. Boston and London: Shambhala Publications Inc.

Tubesing, N.L., and Tubesing, D.A. (eds) (1983) *Structured Exercises in Stress Management*. Duluth, MN: Whole Person Press.

Wills, P. (1993) *Colour Therapy*. Rockport, MA: Element Books, Inc.

Wong, W. (1972) *Principles of Two-Dimensional Design*. New York: Van Nostrand Reinhold.

Yungblut, J.R. (1995) *The Gentle Art of Spiritual Guidance*. New York: Continuum.

Further Reading and Resources

Cameron J. (1992) *The Artist's Way: A Spiritual Path to Higher Creativity*. New York: Jeremy P. Tarcher/Perigee.

Cappicione L. (1979) *The Creative Journal*. Athens, OH: Swallow Press.

Cassou, M. and Cubley, S. (1995) *Life, Paint, and Passion*. New York: Jeremy P. Tarcher/Putnam.

Cornell, J. (1994) *Mandala: Luminous Symbols for Healing*. Wheaton, IL: Quest Books.

Craig, D. (1993) *A Miscellany of Artists' Wisdom*. Philadelphia, PA: Running Press.

Diaz A. (1992) *Freeing the Creative Spirit: Drawing on the Power of Art to Tap the Magic and Wisdom Within*. San Francisco, CA: Harper.

Dunn, C. (1995) *Conversations in Paint*. New York: Workman Publishing.

Fincher, S. (1991) *Creating Mandalas*. London: Shambhala Publications Inc.

Fox, J. (1997) *Poetic Medicine*. New York: Jeremy P. Tarcher/Putnam.

Ganim, B. and Fox, S. (1999) *Visual Journaling*. Wheaton, IL: Quest Books.

Gerding, J. (2001) *Drawing to God*. Notre Dame, IN: Sorin Books.

Gold, A. (1998) *Painting from the Source*. New York: Harper Collins.

Hieb, M. (1995) *Art-Journaling Video*. Canfield, VT: Alba House Communications.

Leslie, C.W. and Roth, C. (1998) *Nature Journaling*. Pownal, VT: Storey Books.

Maisel, E. (2002) *Fearless Creating*. New York: Jeremy P. Tarcher/Putnam.

McCreight, T. (1996) *Design Language*. Portland, ME: Brynmorgen Press.

Warner, S. (1994) *Making Room for Making Art*. Chicago, IL: Chicago Review Press.

For information and resources available on the *ministry of spiritual direction*, contact

Spiritual Directors International
P.O. Box 584
Bellevue, WA USA 98009-3584
www.sdiworld.org

For information and resouces available on a wide range of *creative arts in therapy*, contact

Arts in Therapy Network (an online international community)
www.artsintherapy.com

Two of the many invaluable contacts available on the Arts in Therapy Network website are:

The British Association of Art Therapists
24–27 White Lion Street
London N1 9PD, UK
info@baat.org

The American Art Therapy Association
1202 Allanson Road
Mundelein, IL USA 60060-3808
info@arttherapy.org

Subject Index

Author Index